In China, My Name Is...

BY VALERIE BLANCO & ELLEN FEBERWEE

In China, My Name Is…
© 2009 Valerie Blanco & Ellen Faberwee

Design: Carolyn Frisch
Typefaces used: Aurora BT, Futura, Helvetica Neue

Every effort has been made to trace accurate ownership
of copyrighted text and visual materials used in this book.
Errors or omissions will be corrected in subsequent editions,
provided notification is sent to the publisher.

Library of Congress Control Number: 2008929884

Printed and bound in China through Asia Pacific Offset

10 9 8 7 6 5 4 3 2 1 First edition

This edition © 2009
Mark Batty Publisher
36 West 37th Street, Suite 409
New York, NY 10018
www.markbattypublisher.com

ISBN: 978-0-9799666-7-5

Distributed outside North America by:
Thames & Hudson Ltd
181A High Holborn
London WC1V 7QX
United Kingdom
Tel: 00 44 20 7845 5000
Fax: 00 44 20 7845 5055
www.thameshudson.co.uk

In China, My Name Is...

BY VALERIE BLANCO & ELLEN FEBERWEE

MARK BATTY PUBLISHER | NEW YORK CITY

CHINA

China: an emerging world power, a land of diversity, opportunities, rich culture. Since the open-door policy initiated in the 1980s, China has developed at a rapid pace with economic growth soaring between 9 and 12 percent every year. Many opportunities came forth from international trade and made Chinese incomes and living standards rise. The Chinese market, which is now structured according to a more market-driven system, created new chances for the Chinese people to pursue individual wealth and growth.

During the era before the open-door policy it was difficult for Chinese to have contact with foreigners. The West was seen as bourgeoisie and did not go hand-in-hand with the ideas of Chinese communism. China dissociated from the outside world. When China opened up, communication with foreigners became regular. With that, cultural differences and misunderstandings in language arose, as the Chinese culture is complex and the language difficult to pronounce. If a word is pronounced incorrectly it will have a completely different meaning. For example, "horse" becomes "marijuana" or "to ask something" becomes "kissing." For foreigners these mistakes make for hilarious moments but for Chinese it can often be insulting toward its culture or can even be considered a personal slight.

Chinese people regard the choice of names as extremely important since names represent powerful associations and symbolism. A name in China carries so much meaning that Chinese believe it has a strong association with their destiny; the words for "name" and "destiny" are even pronounced the same: *ming*. The choice of characters in a name is important. With the right set of characters you can influence your fate. We met a woman who explained how her parents felt she lacked fire because of her Chinese zodiac. They added the symbol for fire to her name. This way they gave her what she needed in life to become successful.

Furthermore, Chinese believe relationships need to be smooth. The start of a relationship is not effortless if a Chinese name is too difficult to remember or to pronounce. How then can the end result be good? For all of these issues the Chinese have a practical solution: they adopt an English name. A small group of very rich and important Chinese has done this for years, but with the rapid developments many people from different social layers in the society are suddenly choosing an English name.

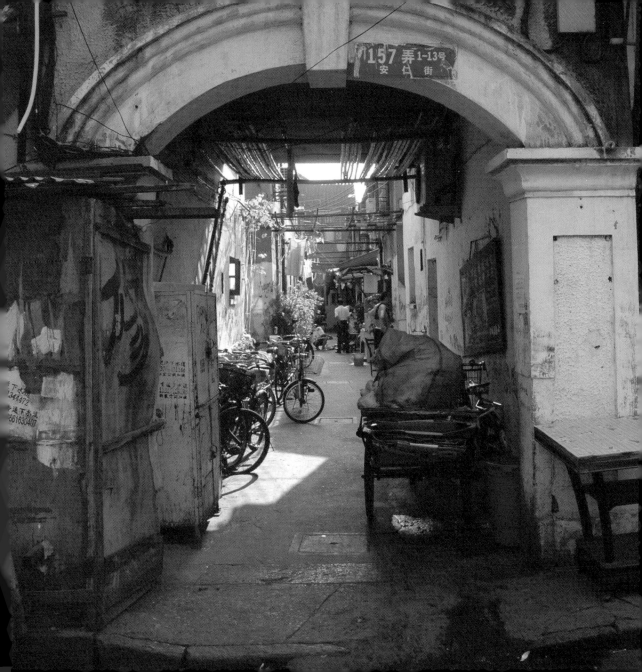

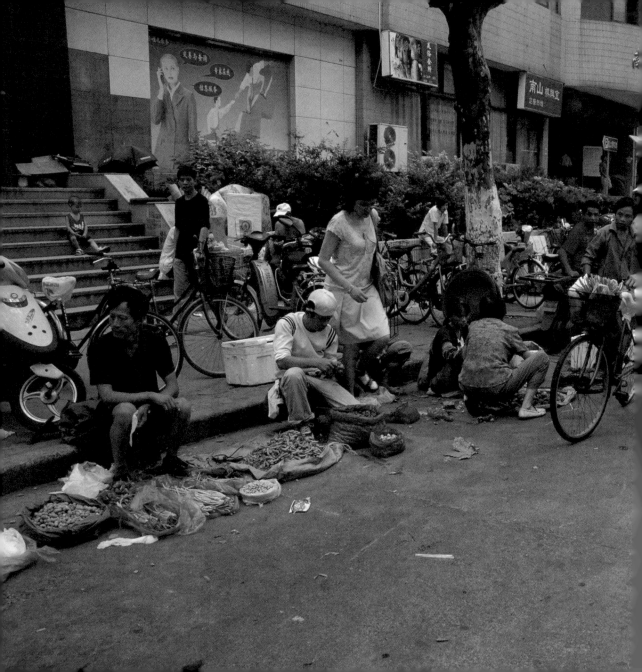

SHANGHAI 2007

We are traipsing through this bustling city passing commercial streets and suburbs, universities, parks, markets, old back alleys, primary schools and office buildings. Like predators we are roaming between hundreds of Chinese people in search of potential victims to interview. Everybody is moving fast but we are watchful and ready to strike with camera and tape recorder. We spot a couple and pounce. In our most basic Chinese we ask them if they have an English name: *"Nimen hao, women you yige wenti. Nimen you meiyou yingwen mingzi ma?"* "Yes, we do. My name is..." From here on we had the most wonderful conversations and had the privilege to meet great people. It was an unforgettable time. We learned about the Chinese culture, the language and its people. We experienced positive and negative moments but most importantly, we had fun. Most were curious to talk to us. Some were shy at the beginning but then opened up. A few walked on without any reaction. Several just giggled.

How did we come up with the idea to create this book? While living in Shanghai as two Dutch women, we experienced the fast economic developments in China. We wondered what the consequences might be of this rapid development on the Chinese. We figured that the opening up of China to the rest of the world must influence its culture. But what influence? One striking observation was that many Chinese are adopting English names. These English names aren't just nicknames but are now often used by many in daily life. We became curious and asked ourselves, "What is the reason for choosing an English name?" Is it for communication purposes or does it carry a deeper meaning like their Chinese name has?

Name giving is an important pillar of Chinese society and part of their cultural heritage. Literally everything in China has a meaning or story behind its presence. So why are Chinese adopting a foreign name that often has no important meaning at all in Western society? Is the Chinese culture changing? Or is this China's reaction to becoming an international player?

Eager to find out more we decided to hit the streets of Shanghai, seeking answers to our questions. Being the financial center of China, Shanghai is a melting pot, attracting people from all over the country. This gave us the chance to provide a broad perspective on the subject. We spoke with Chinese from different provinces and "social layers": poor street workers, visitors off the Millionaires' fair, monks, students.

We envisioned creating something pure, giving you the locals' stories instead of a foreigner's point of view. Looking at the developments from the perspective of the Chinese people gives a deeper meaning since Chinese culture has complexities, which are difficult for a foreigner to capture and understand. Since we present their stories we used their words, spelling and grammar. Most of the interviews are literally translated from Chinese into English. Some interviews took place in English so we wrote down their exact wordings. As a result, some of the English sentences are not always complete. Within all of these portraits and interviews you can see Chinese peoples' professions, lifestyles, fashions, thoughts, dreams and hopes. While looking in their eyes you can catch a glimpse of China's future. It becomes a real story; something that we value.

My Name Is... looks into a serious topic with a touch of intimate humor. This was not done on purpose but occurred because the Chinese are great people, curious and friendly. We have a deep respect for the culture and its people who were part of giving us an unforgettable time. *Xie xie nimen.* Thank you all.

CHOOSING AN ENGLISH NAME: OUR EXPERIENCES

Easier communication with foreigners is still one of the main reasons why Chinese people adopt English names. However, besides communication purposes, there is also a shift toward "showing off" your status in society. Many Chinese feel that having an English name shows that you are part of the new class in China; you probably went to university, can be considered fashionable or are expected to work as a high paid "white collar" in one of the large foreign multinationals. Differences in status have been part of the Chinese culture for centuries. Since the modernization policy, the gap between rich and poor has been growing and the cities are developing faster in comparison to rural areas. Therefore, differences in status have become an even larger issue. In China, to "show off" your status is a way to set yourself apart from the poor people who are becoming poorer. Nowadays, choosing an English name doesn't always mean you can speak English or have actual contact with foreigners.

Of course not everybody chooses an English name. The young urban generation is by far the largest group that adopts English names. They are more modern than previous generations and are used to influences from the Western world. Chinese are basically very nationalistic and proud of their culture. This can be a reason for not choosing an English name. Various Chinese told us, "I don't need an English name" or "I like my Chinese name." These traditional thinkers

could have foreign friends but they seem to find their personal identity more important.

There are many different ways of choosing an English name. For many Chinese the choice is as important as their Chinese name. Collectiveness is still a significant aspect of Chinese society. People want to be individuals and express themselves but within their social group they want to be respected. While collecting these people's stories we realized the choice of an English name, for Chinese, is often based upon what important people, like family, friends, employees and teachers, like or think will fit somebody's character. Many Chinese choose a name picked jointly by these people. For example, many Chinese got their names through their teacher during English classes or through their work from their (foreign) manager.

The dictionary is often used for choosing a name. In China you have special dictionaries with translations of Chinese names into English. We also met Chinese who like to be unique and picked a name on their own. They just make them up and often choose distinctive names, such as "Rubberpixy" or "Star." They can also choose an identity that has a connection with their Chinese name or surname. We interviewed a girl called Candy. She chose this name because her Chinese surname is Tang (糖), which means sugar or sweet. Some Chinese even

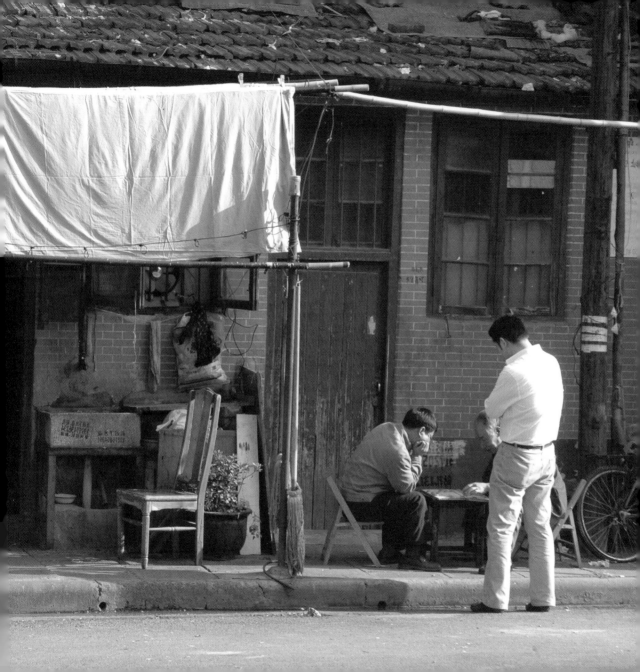

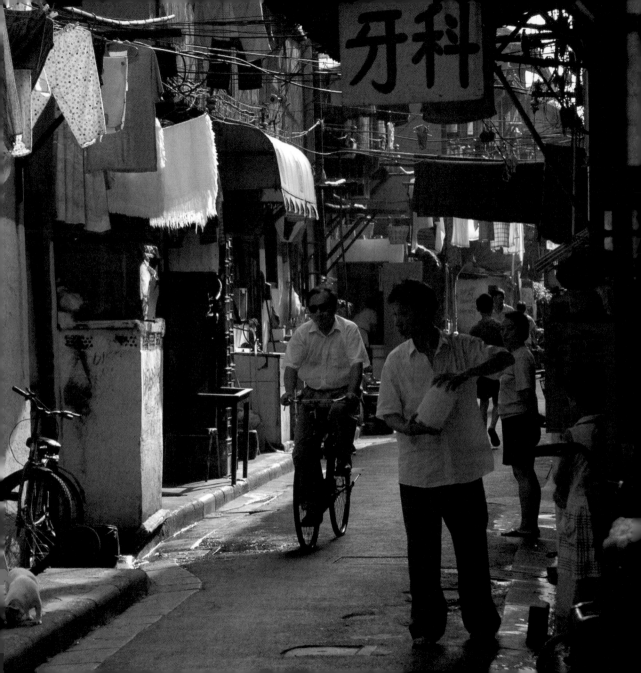

have almost the same Chinese and English name, like "Tiffany"; her Chinese name is pronounced as "*Da Fen Ni.*"

Destiny is another important aspect in choosing a certain English name. We met Chinese that adopted an English name that will give them a fortunate destiny. Chinese often use icons to choose a name, like a successful singer or businessman. In this book we include a man who calls himself "Billy" because of Bill Gates.

Finally, Chinese think the way of pronouncing a certain name is important. It should sound good. For guys, for example, it can be important that the name is pronounced in a strong masculine way, like "Jack." Chinese like the pronunciation of names that end with a "y." This is a reason why so many Chinese in this book have names like "Linky" and "Mary."

The decision to take English names is one of the symbols for a modern generation that is showing a growing sense of individualism. Historically, Chinese society was characterized by collectiveness and equality, but with today's rapid developments it is turning more to individualism where people can choose their identities and express themselves. The West has much influence on the society and culture but the Chinese are nationalistic and like to see China developing into a strong international player. *My Name Is...* shows China introducing itself to the world. On the following pages Chinese will introduce themselves and explain their new identities. We hope you will enjoy this book as much as we enjoyed making it.

From a young age I started to learn English. I chose the name from the first name that I saw in the dictionary. In the Bible I remember there was a person called like this but I am not sure. There is also a singer who is called Aeron. I'm quite like him. During work in real estate, it is convenient to use.

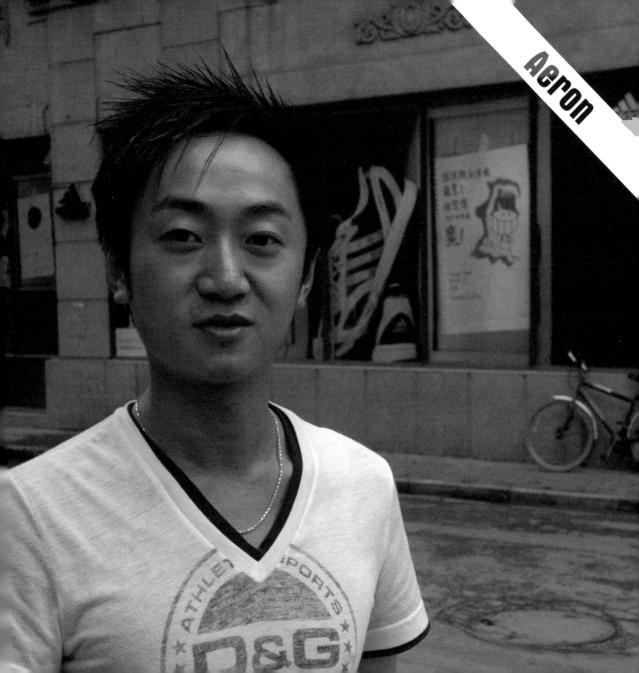
Aeron

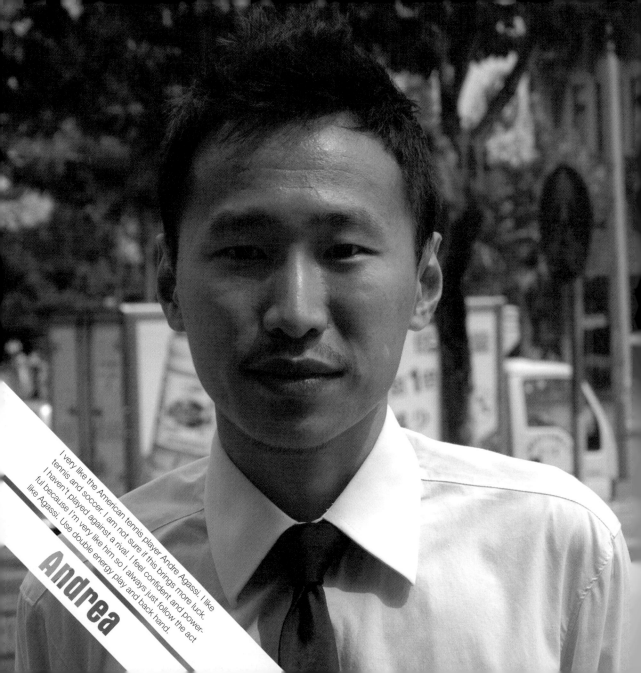

I very like the American tennis player Andre Agassi. I like tennis and soccer. I am not sure if this brings more luck. I haven't played against a rival. I feel confident and powerful because I'm very like him so I always just follow the act like Agassi. Use double energy play and back hand.

Andrea

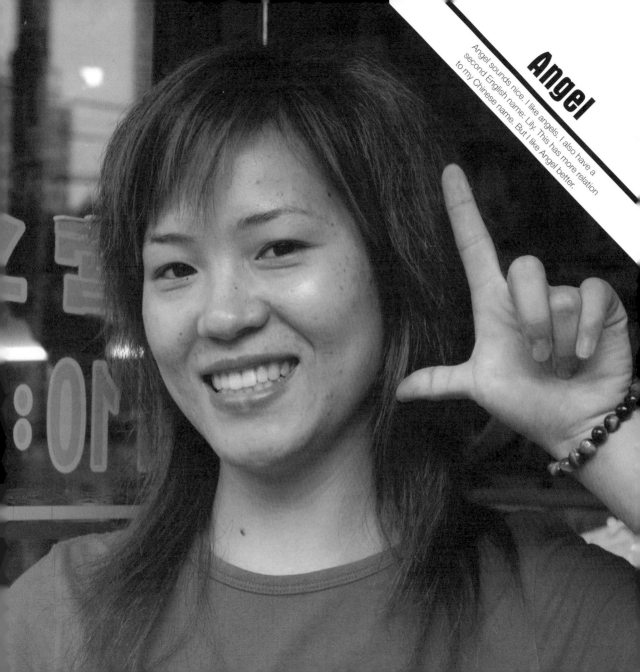

Angel

Angel sounds nice. I like angels. I also have a second English name: Lily. This has more relation to my Chinese name. But I like Angel better.

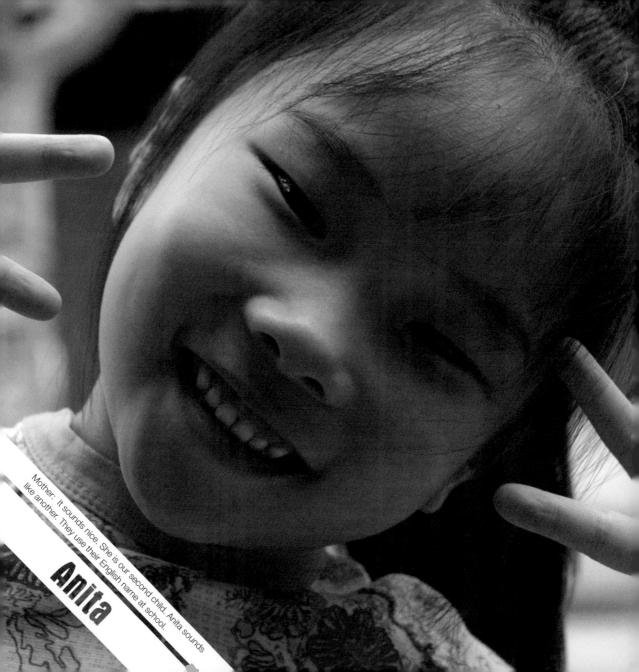

Mother: It sounds nice. She is our second child. Anita sounds like another. They use their English name at school.

Anita

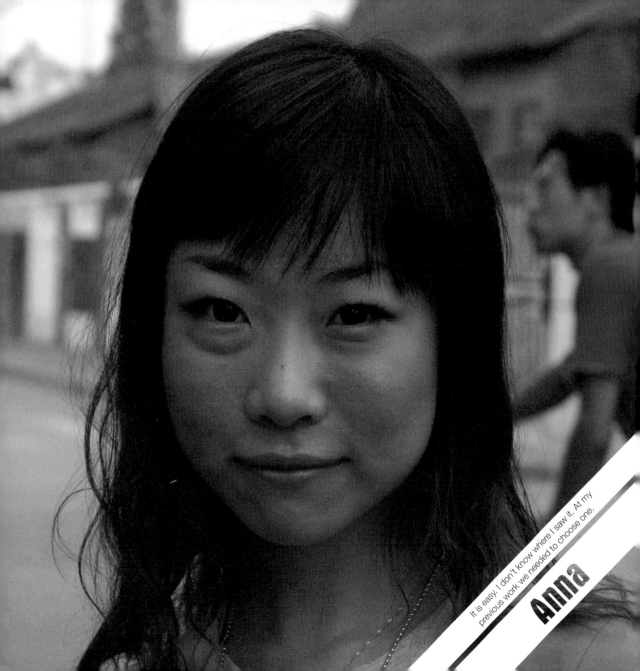

It is easy. I don't know where I saw it. At my previous work we needed to choose one.

Anna

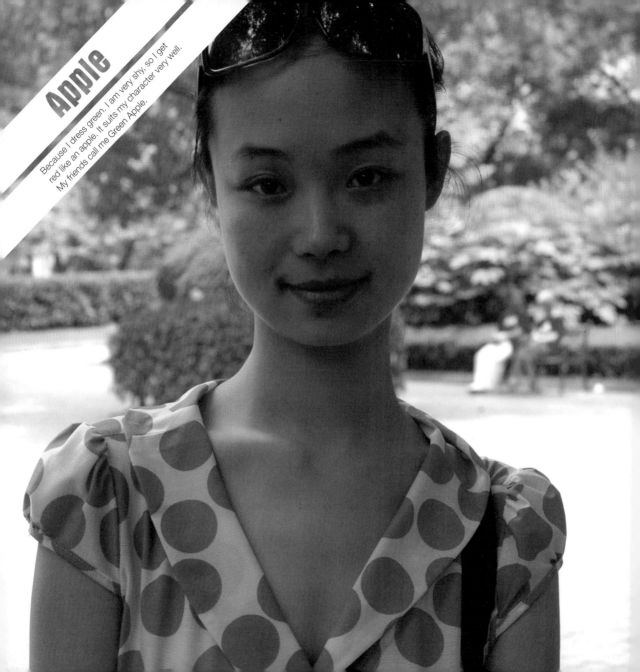

Apple

Because I dress green, I am very shy, so I get red like an apple. It suits my character very well. My friends call me Green Apple.

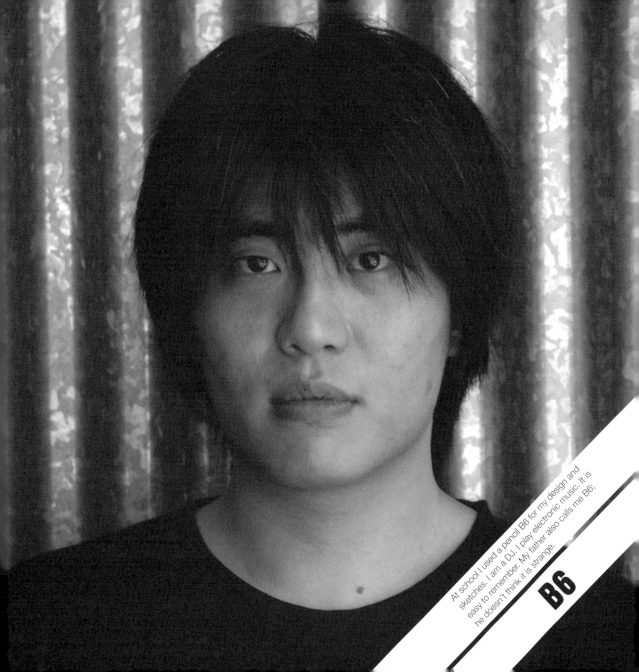

At school I used a pencil B6 for my design and sketches. I am a DJ, I play electronic music. It is easy to remember. My father also calls me B6; he doesn't think it is strange.

B6

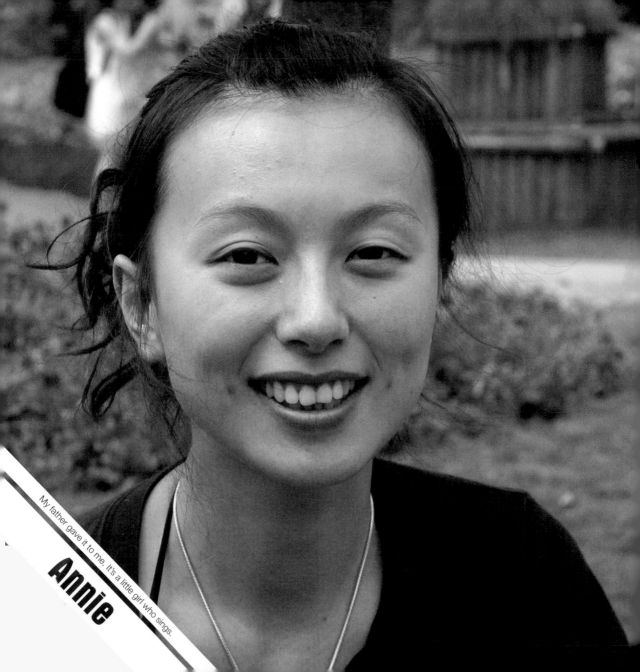

My father gave it to me. It's a little girl who sings.

Annie

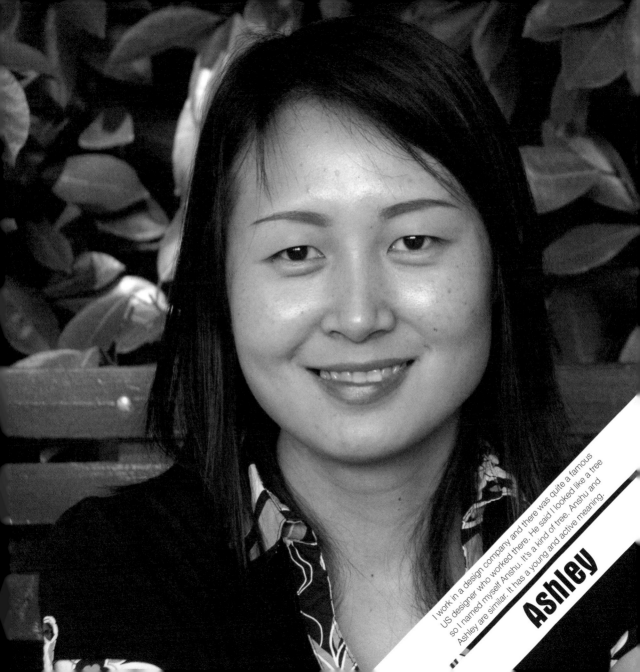

I work in a design company and there was quite a famous US designer who worked there. He said I looked like a tree so I named myself Anshu. It's a kind of tree. Anshu and Ashley are similar. It has a young and active meaning,

Ashley

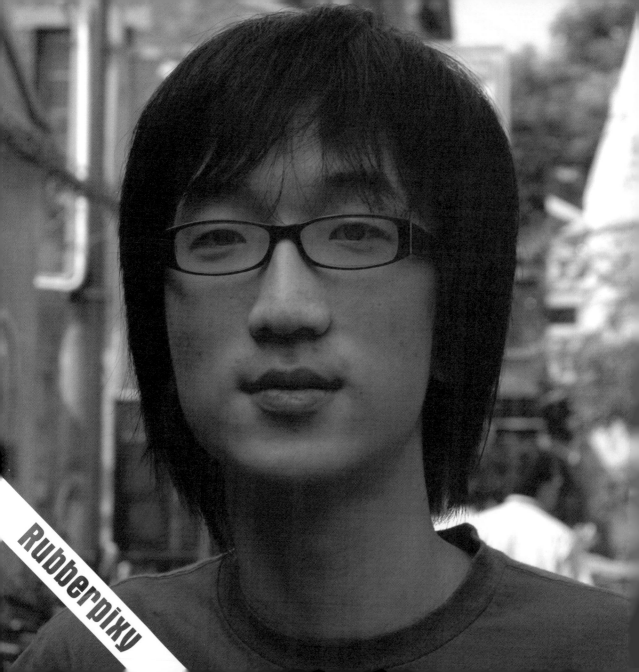

This studio is called SAS: Shanghai Artist Studio. Our slogan is "design to the people." I am the chief designer and I make graphics. I also do freelance projects with my friend Ben. We are called GAGAS. The Chinese characters, in the Mandarin version of this name, mean: "plus," "and" and "series." If you pronounce these characters in Shanghainees dialect it sounds like GAGAS. For us it is important that the name has a positive meaning; we want to be lucky in our corporation together.

Rubberpixy: because I am like a rubber band. A rubber band is laid back and normal but it can be extremely tensed when you pull it. If you release the band it will bounce to every direction. I think I can make something big.

I think rubber band doesn't sound nice as a name. Therefore I chose Rubberpixy. Pixy comes from pixels.

I use this name because it is convenient to communicate on the internet. Besides, people will easy recognize me when I make graphic work. My Chinese name means bright and open. All my friends call me Rubberpixy. My parent's don't call me like that; they call me by my Chinese nickname.

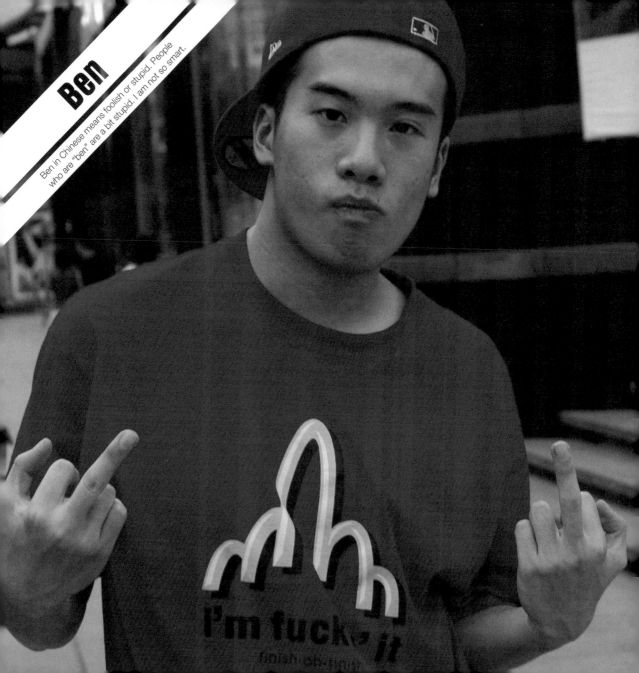

Ben

Ben in Chinese means foolish or stupid. People who are "ben" are a bit stupid. I am not so smart.

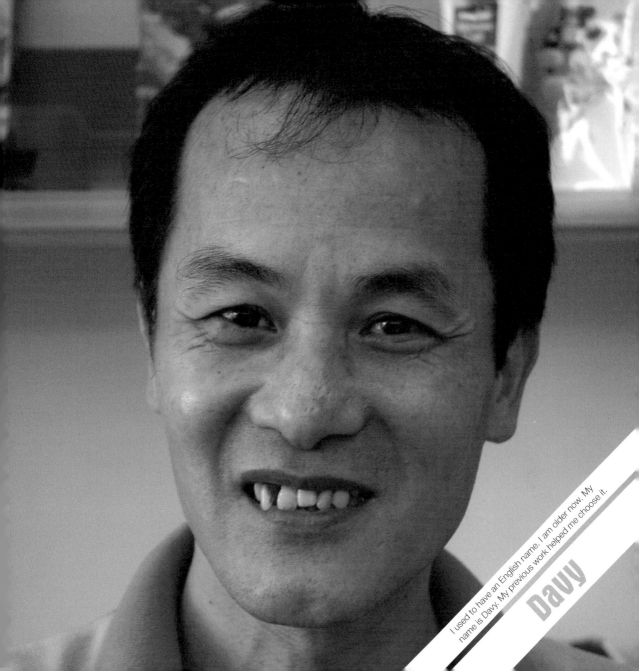

I used to have an English name. I am older now. My name is Davy. My previous work helped me choose it.

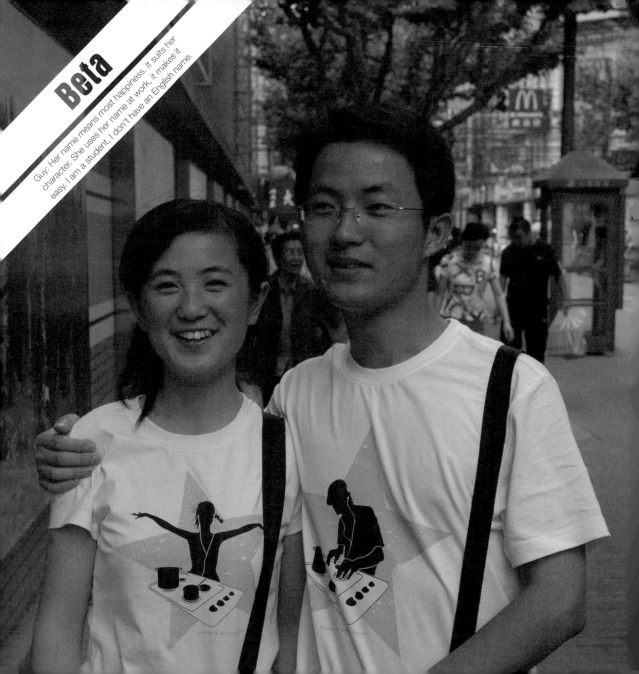

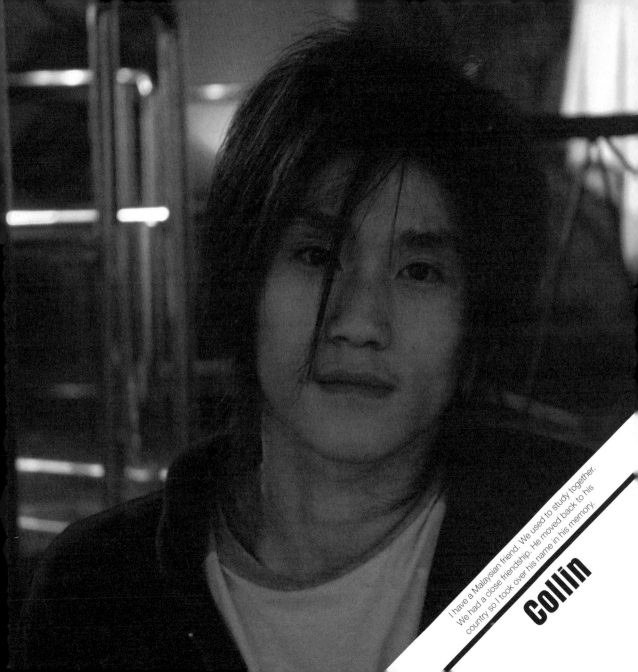

I have a Malaysian friend. We used to study together. We had a close friendship. He moved back to his country so I took over his name in his memory.

collin

I graduated from Tongji University. My major is science and technology. I played a lot of games, some powerful roles in games called Billy. Also the CEO of Microsoft Company is Bill so I just added "y." I want to get some job in IT related company. After graduation I chose an English name with my first job. I had to choose one. I thought it is useful to use an English name. A Chinese name is so complicated to pronounce. English more easily. I use my English name with some friends and old colleagues. It is normal, easy and acceptable to use an English name. Especially in a foreign or Hongkongnese company.

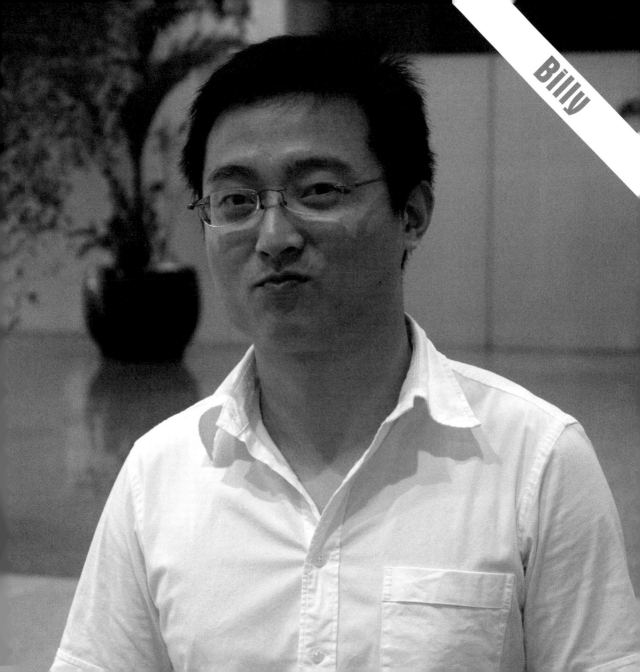

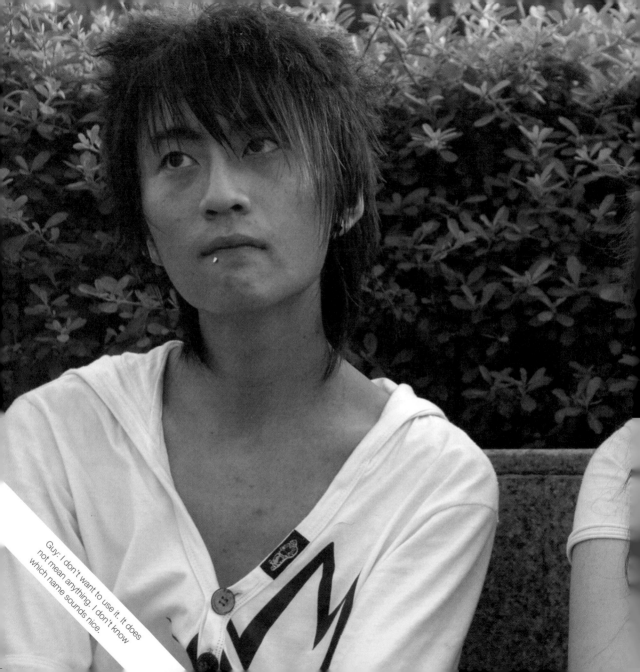

Guy: I don't want to use it. It does not mean anything. I don't know which name sounds nice.

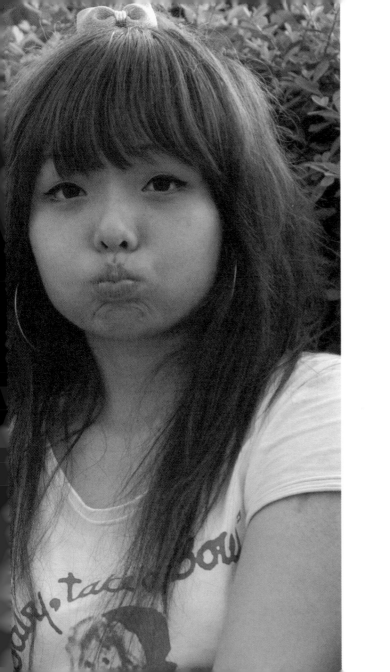

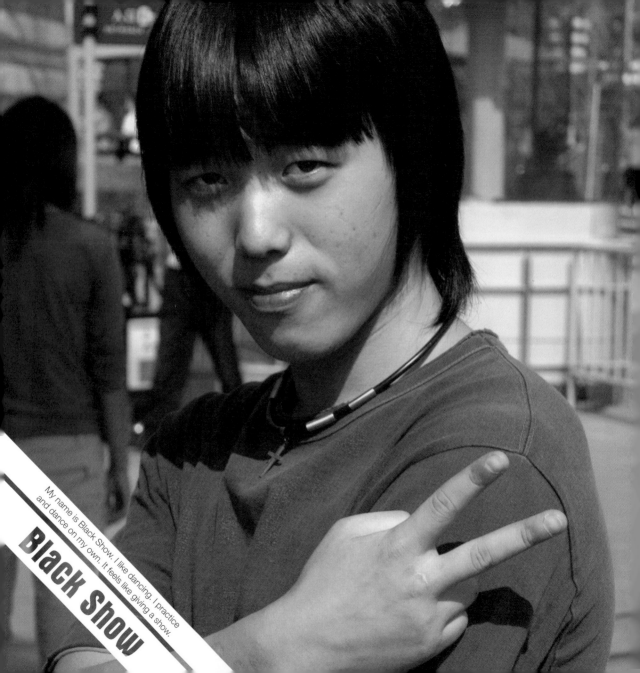

My name is Black Show. I like dancing. I practice and dance on my own. It feels like giving a show.

Black Show

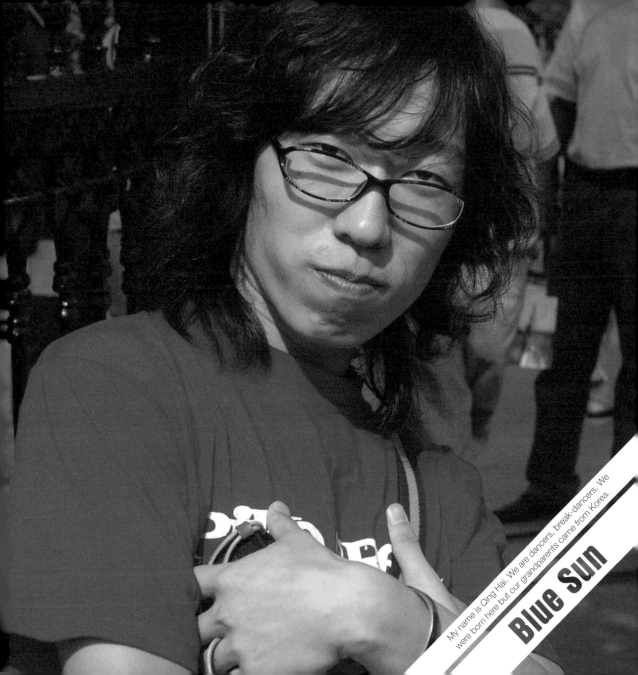

My name is Qing Hai. We are dancers, break-dancers. We were born here but our grandparents came from Korea.

Blue Sun

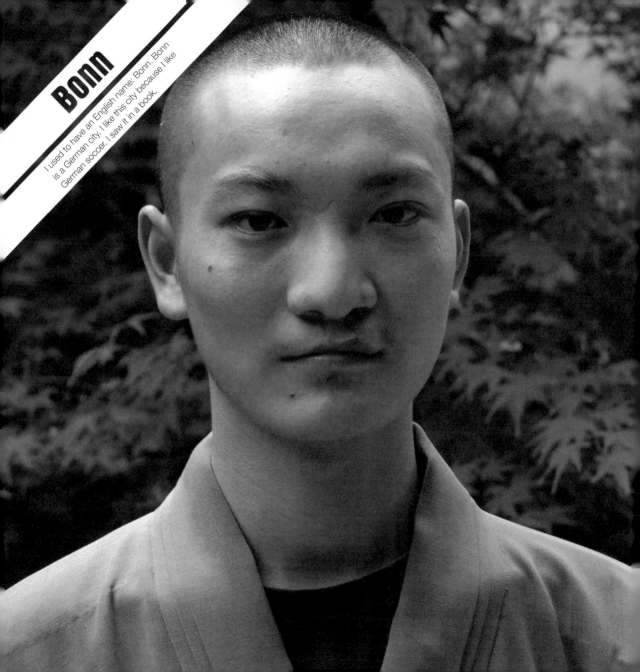

Bonn

I used to have an English name: Bonn. Bonn is a German city. I like this city because I like German soccer. I saw it in a book.

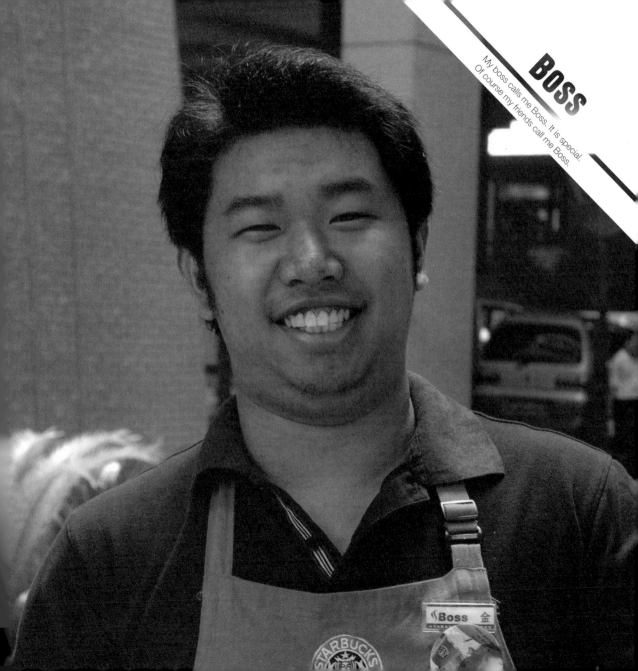

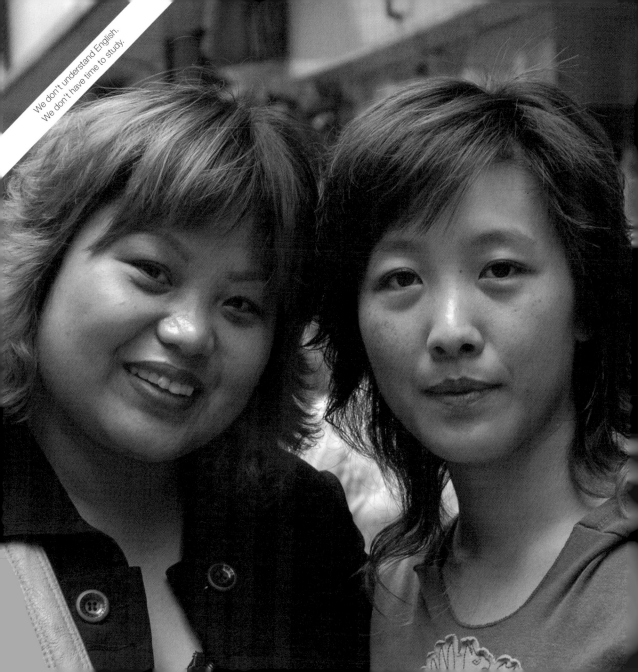

We don't understand English.
We don't have time to study.

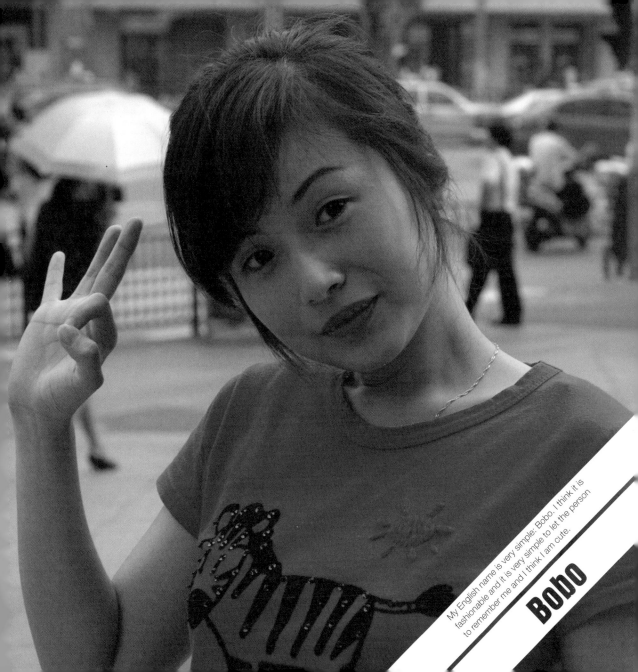

My English name is very simple: Bobo. I think it is fashionable and it is very simple to let the person to remember me and I think I am cute.

Bobo

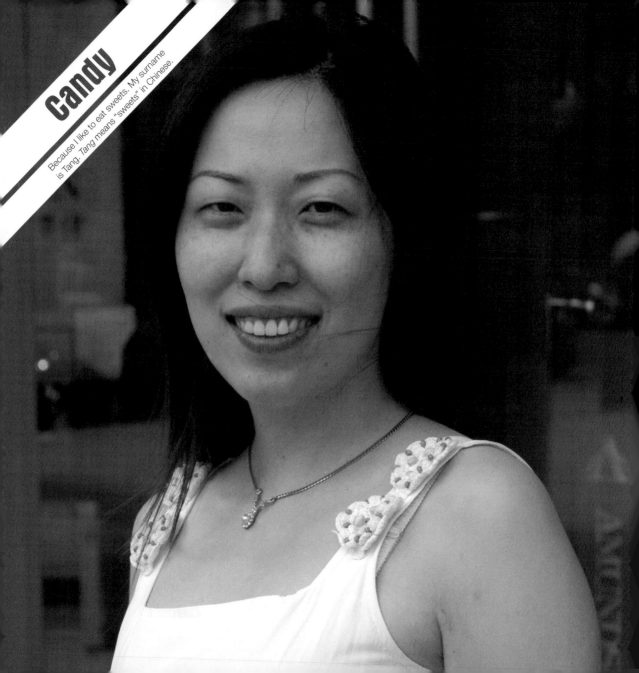

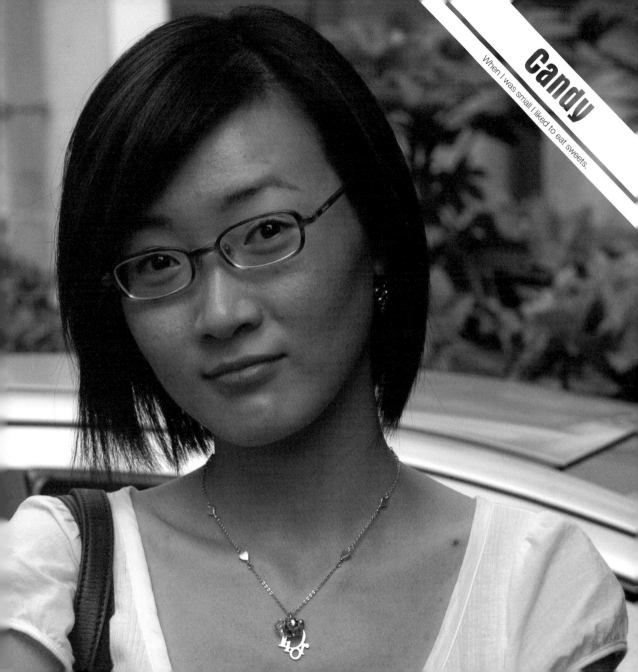

Candy

When I was small I liked to eat sweets.

I choose the name from the dictionary and I choose the name because I want to be unique. Most of the Chinese people they choose the English name to be simple and to be easy to remember but I just want people to remember my name for a long term. Maybe just from the spelling it is more English style. It has no connection with my Chinese name it is just my personal favorite. I chose the name when I was young and it is hard to discover what is the background of the meaning.

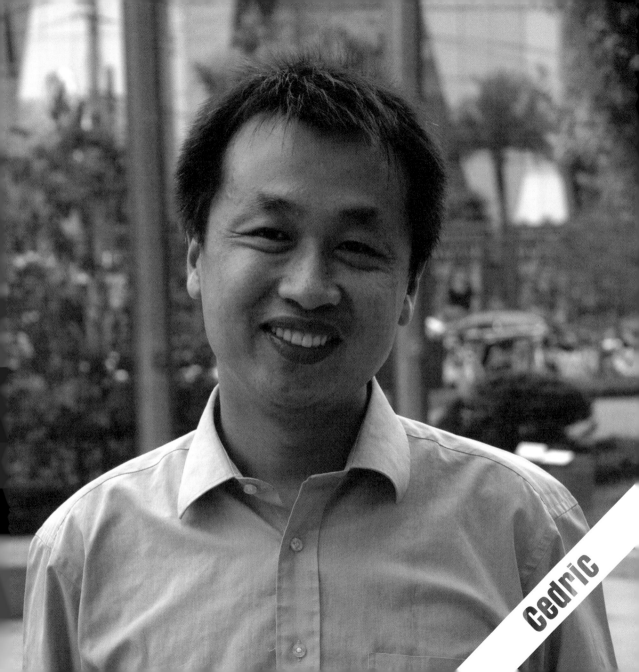
cedric

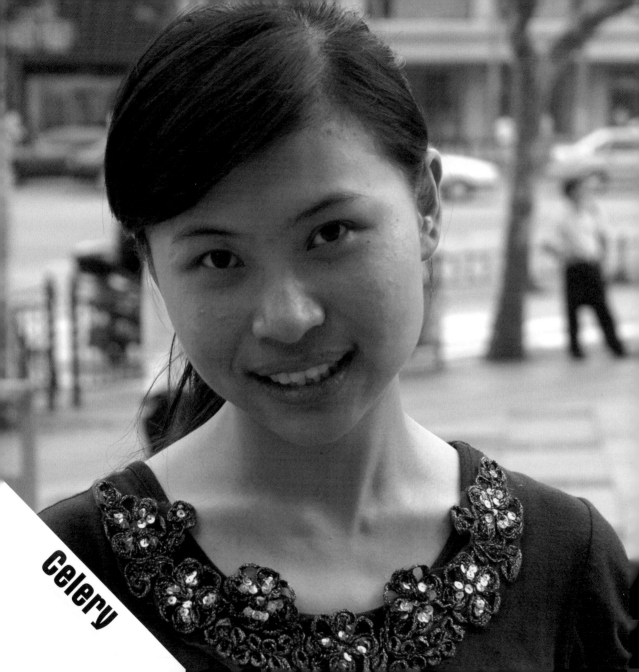

celery

Dear,

Sorry I didn't give you a proper description of my English name yesterday. I hope this message will be helpful for your book.

Well, let me say something about my name Celery. Yeah, it's Celery, not Salary. It should be the vegetable celery.

My Chinese name is Wang Qin. The "qin" is the word for "celery" in Chinese. When I was a child, I really did not like my name, because others always laugh at my name. Actually, celery has her special meaning in Chinese.

Long time ago, there was a rich man who extremely likes eating celery. One day he gave celery to the emperor as a tribute. But the emperor didn't like celery. People laughed at him sent such a cheap and tasted bad thing to the emperor. So celery stands for the worthless thing. You know Chinese people are so modest, after that, we use celery to show our modest when we give someone a present. The writer Cao Xueqin of the Story of the Stones (*A Dream Of Red Mansions*), one of the most famous classic novels of China, uses Celery as his pseudonym.

But today rare people know celery has such a special meaning except my parents. Well, just kidding. They named me Celery, which shows they want me to be a modest and kind people. I think I will do so.

That's why I kept the special name as my English name. Yeah, please call me Celery, although someone thinks it is ridiculous or it sounds really like Salary....(Am I a money worship guy :-)).

Ok, that is it. Have a nice day.

Cheers

Celery Wang

Charles (left): It has a connection with my Chinese name: Zhang Qiu Shi. An uncle in Hong Kong gave it to me. I use it for learning English and it is also good for later when I have more foreign friends.

Jerry (right): I used to watch Tom & Jerry a lot. I like these cartoons very much.

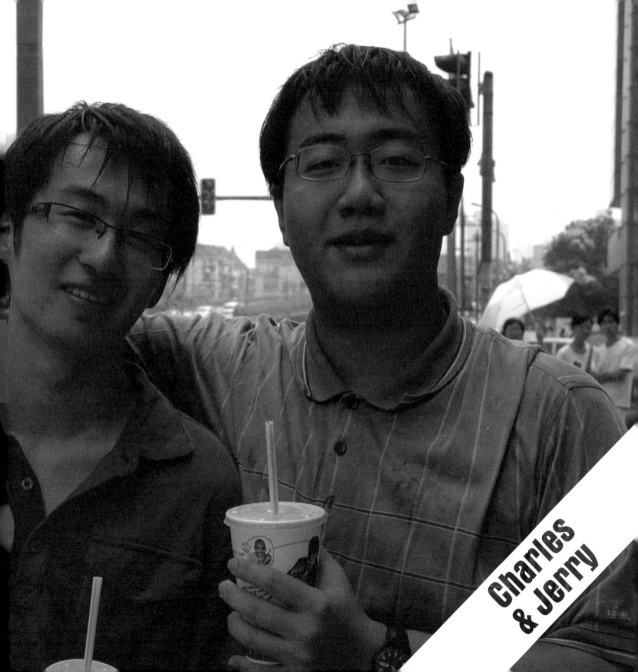

Charles & Jerry

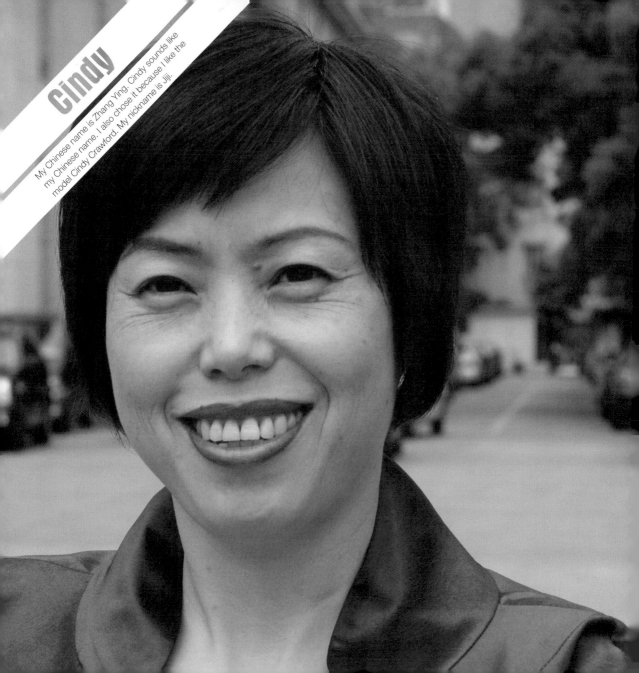

Cindy

My Chinese name is Zhang Ying. Cindy sounds like my Chinese name. I also chose it because I like the model Cindy Crawford. My nickname is Jiji.

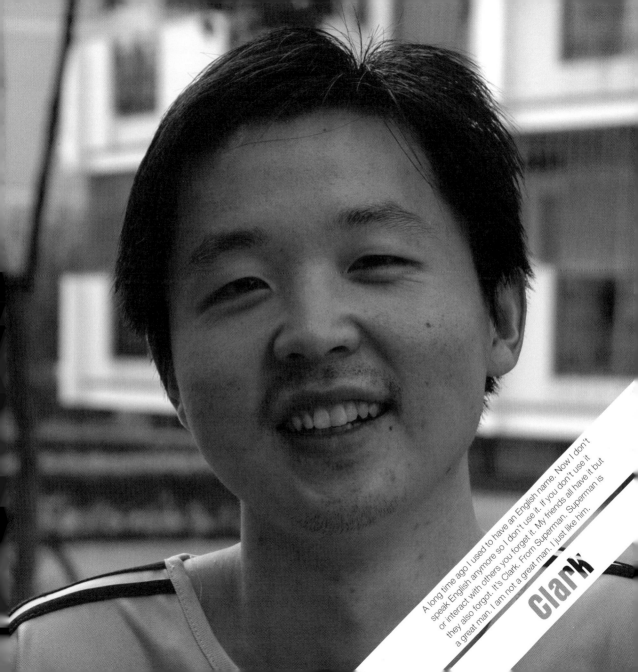

A long time ago I used to have an English name. Now I don't speak English anymore so I don't use it. If you don't use it or interact with others you forget it. My friends all have it but they also forgot. It's Clark. From Superman. Superman is a great man. I am not a great man. I just like him.

Clark

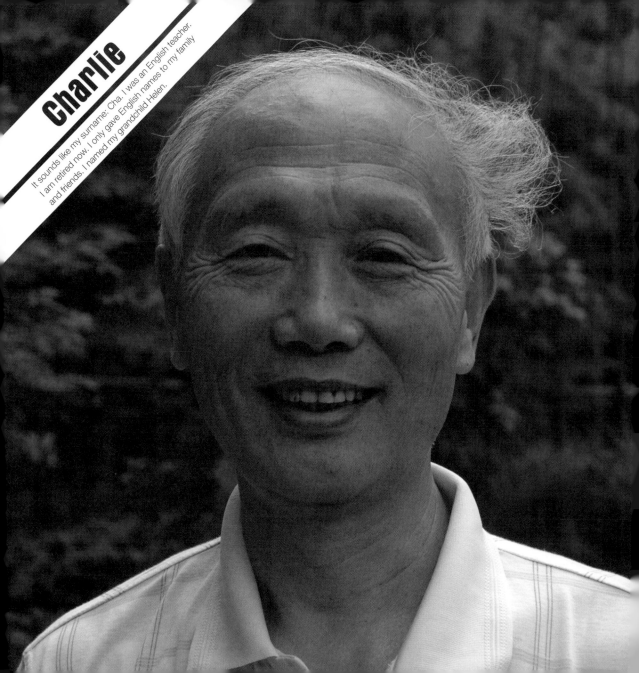

Charlie

It sounds like my surname: Cha. I was an English teacher. I am retired now. I only gave English names to my family and friends. I named my grandchild Helen.

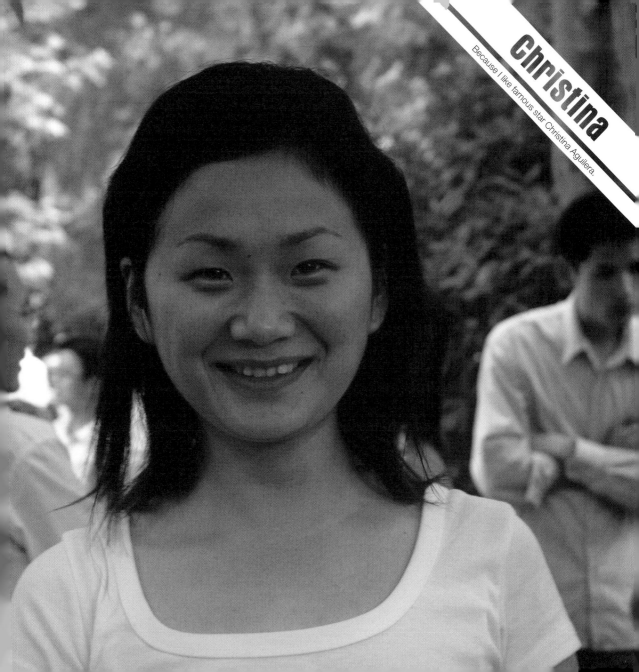

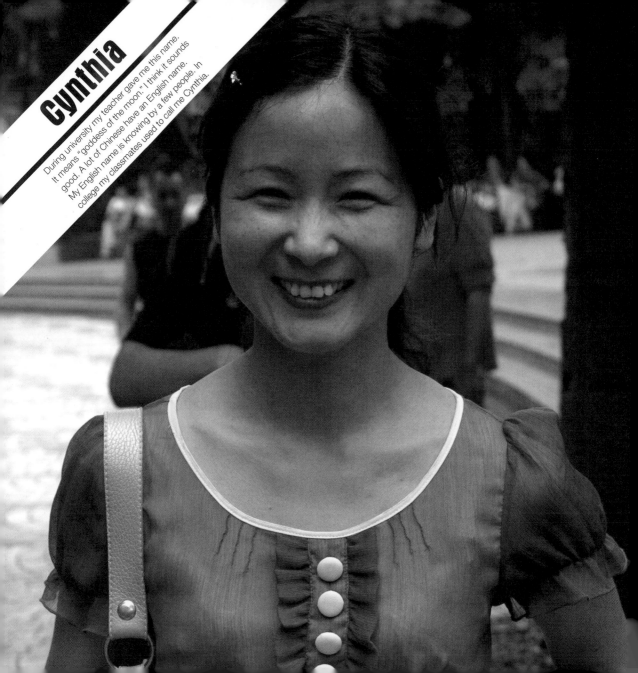

Cynthia

During university my teacher gave me this name. It means "goddess of the moon." I think it sounds good. A lot of Chinese have an English name. My English name is knowing by a few people. In college my classmates used to call me Cynthia.

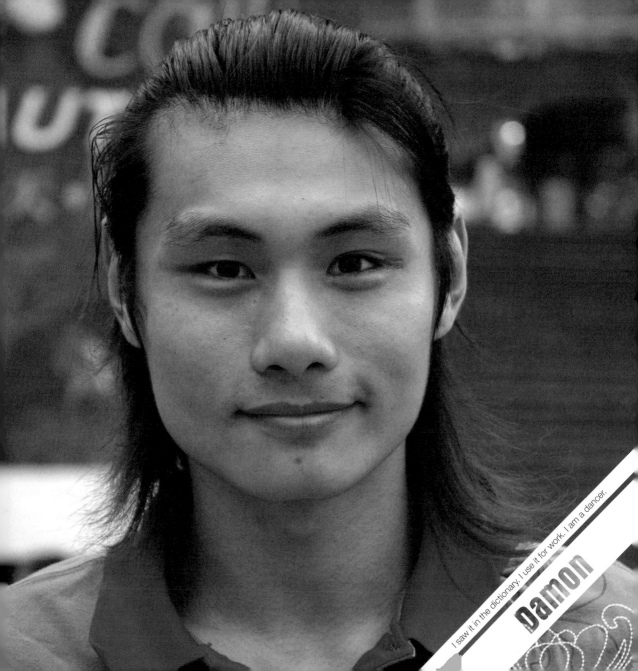

I saw it in the dictionary. I use it for work. I am a dancer.

Damon

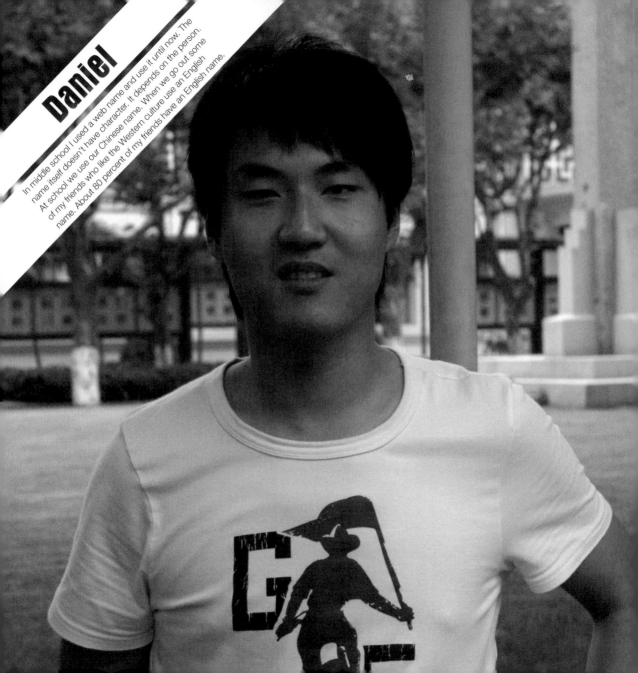

Daniel

In middle school I used a web name and use it until now. The name itself doesn't have character. It depends on the person. At school we use our Chinese name. When we go out some of my friends who like the Western culture use an English name. About 80 percent of my friends have an English name.

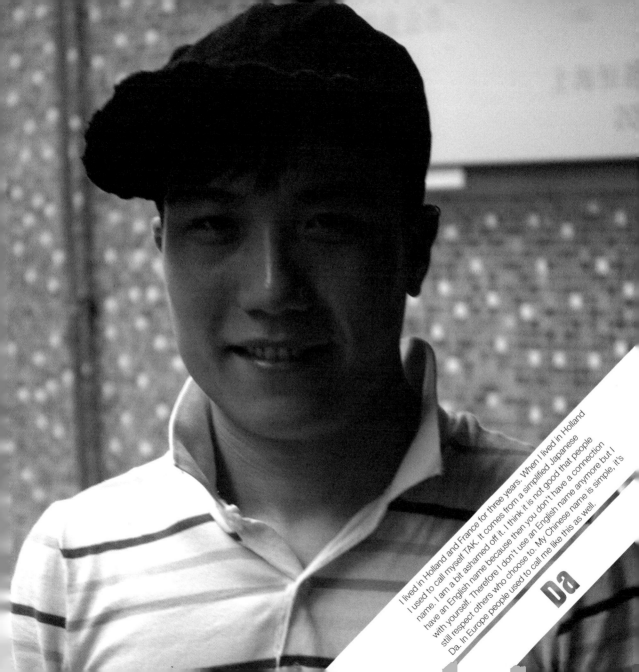

I lived in Holland and France for three years. When I lived in Holland I used to call myself TAK. It comes from a simplified Japanese name. I am a bit ashamed off it. I think it is not good that people have an English name because then you don't have a connection with yourself. Therefore I don't use an English name anymore but I still respect others who choose to. My Chinese name is simple, it's Da. In Europe people used to call me like this as well.

Da

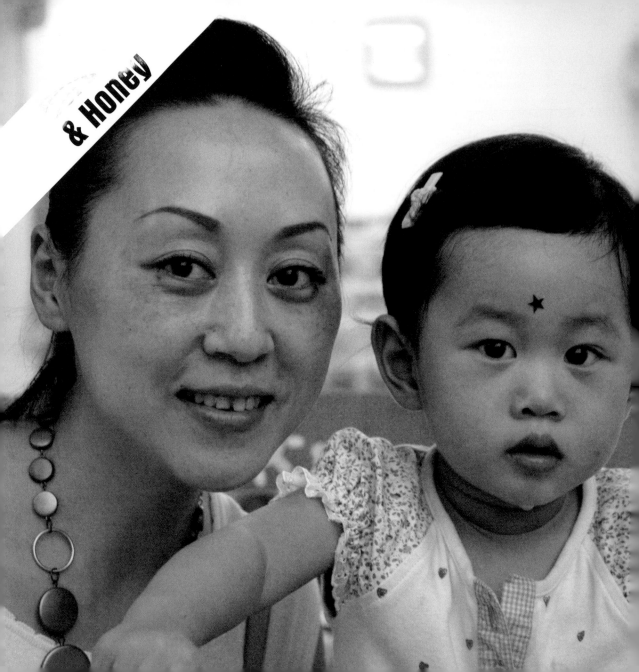

I call her that way now but later it can change. She
is at an educational class for small children to learn
English. The teacher also calls them by their English
name.

My name is Doreen. I chose it when I studied. My
last name is Dong. It is a little bit similar. Foreigners
or my boss can call me easy. My boss is an Austra-
lian. Easy to remember me.

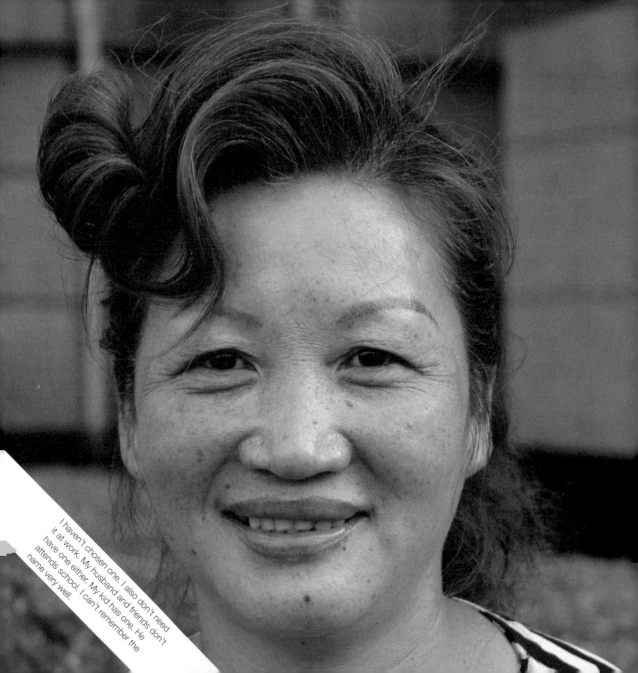

I haven't chosen one. I also don't need it at work. My husband and friends don't have one either. My kid has one. He attends school. I can't remember the name very well.

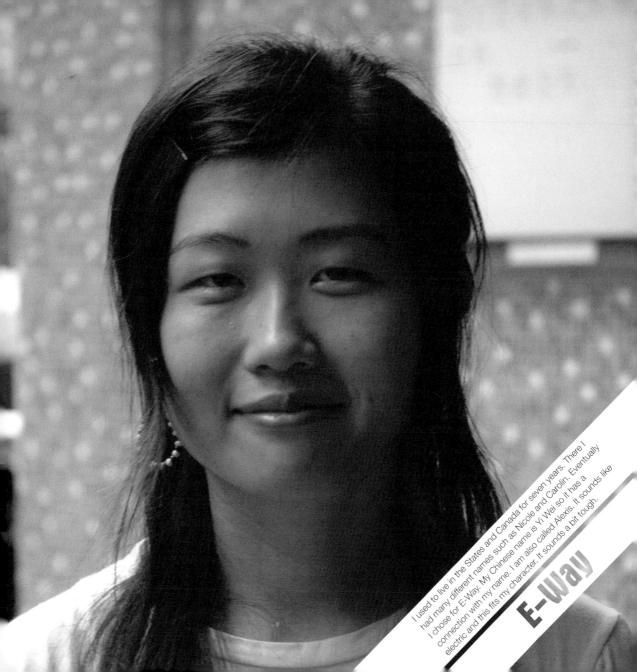

I used to live in the States and Canada for seven years. There I had many different names such as Nicole and Carolin. Eventually I chose for E-Way. My Chinese name is Yi Wei so it has a connection with my name. I am also called Alexis. It sounds like electric and this fits my character. It sounds a bit tough.

E-Way

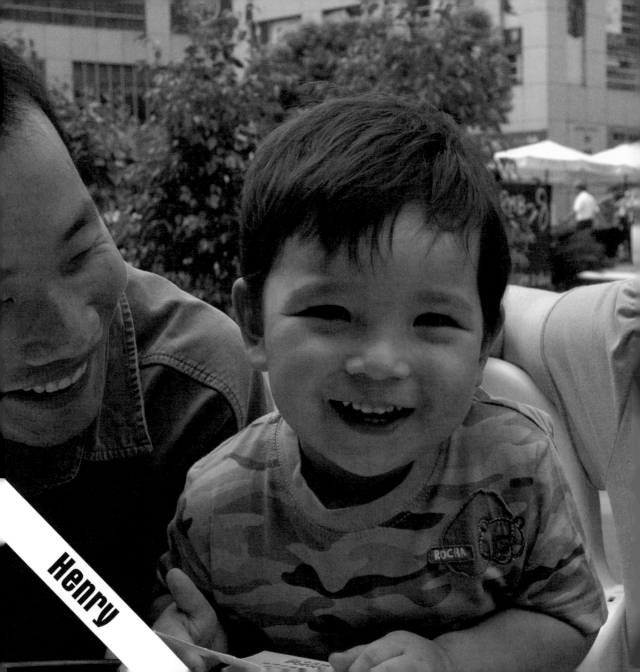

Henry

Mother: His name is Henry. We really thought very carefully about it and we wanted just one name. We wanted a name that worked in both languages and both cultures so his Chinese name is Han Rei. My family obviously says Henry but my husband's families all call him Han Rei. He is not confused. He recognizes it.

Father: Han Rei means the following. In China the majority is Han nationality. I am from Han Ra. Rei can be lucky or smoothly, for good meaning. Henry is also the king of England, haha. We picked the English name first. How does that translate in Chinese? Look for better ways. Henry just jump out of our mind.

I liked a Taiwanese female writer, San Mao, her English name is Echo. I am a teacher so my friend once said a student is the echo of a teacher, so I decided to keep the name.

First my father wanted to call me Wang Yan Qiong but Qiong pronounced in a certain way means poor so they changed it into Wang Ming, which means smart. Old people as well as young people believe in the power of a name.

Lately people are giving their children names, which are pronounced almost the same as Western names. Also a small group is using very special characters. In the past the ideas were less. Names often included meanings with rich, beautiful or smart. Now, choosing less used characters can make you special. Rich and fashionable people who work at foreign companies sometimes call their children by their English name. Mixed couples often use two names. From 2000 suddenly a lot of people used English names.

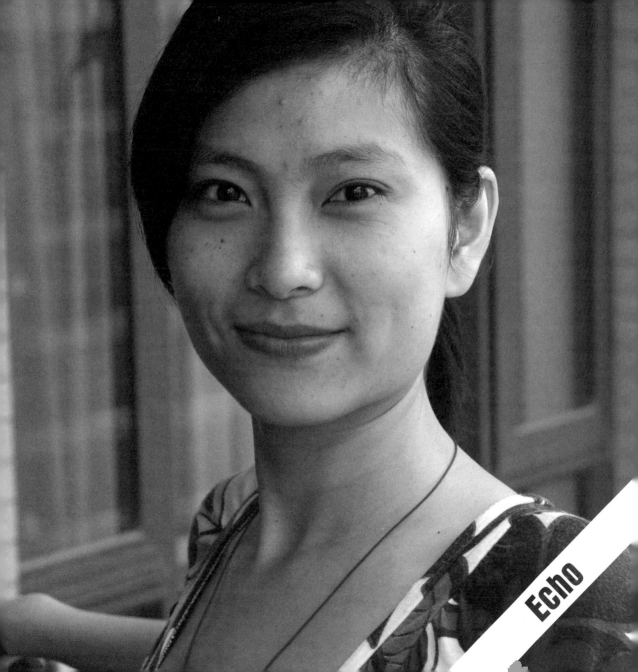
Echo

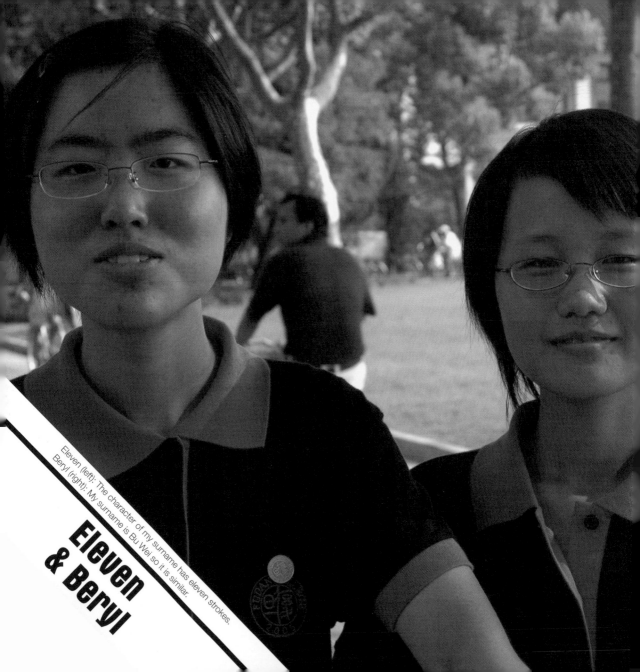

Eleven (left): The character of my surname has eleven strokes.
Beryl (right): My surname is Bu Wei so it is similar.

Eleven
& Beryl

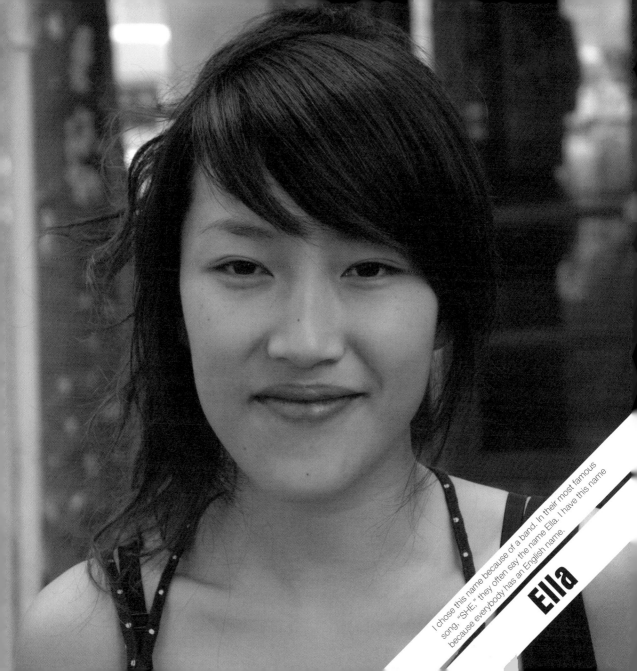

I chose this name because of a band. In their most famous song, "SHE," they often say the name Ella. I have this name because everybody has an English name.

Ella

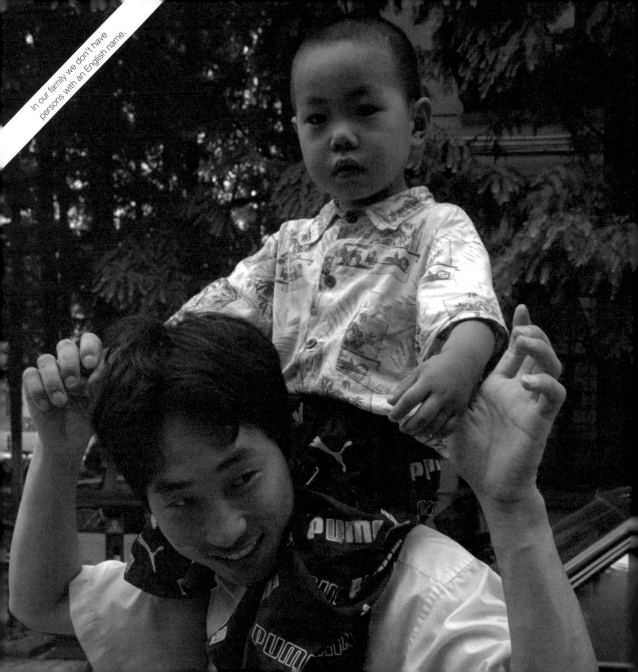

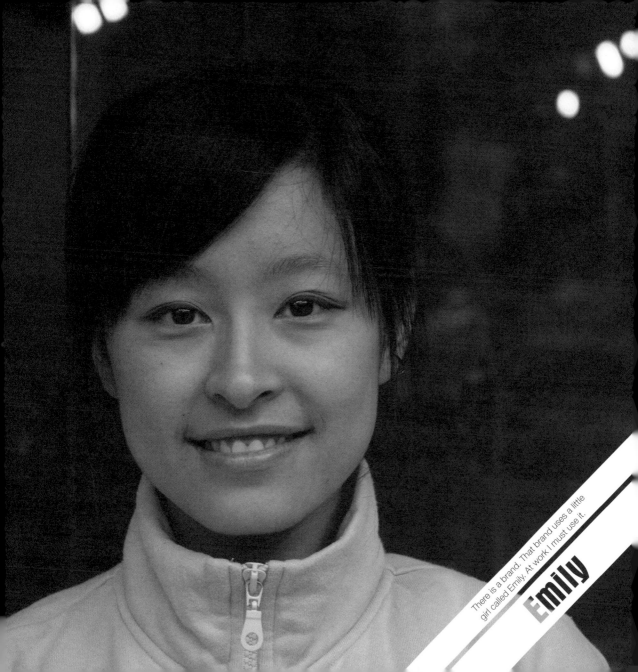

There is a brand. That brand uses a little
girl called Emily. At work I must use it.

Emily

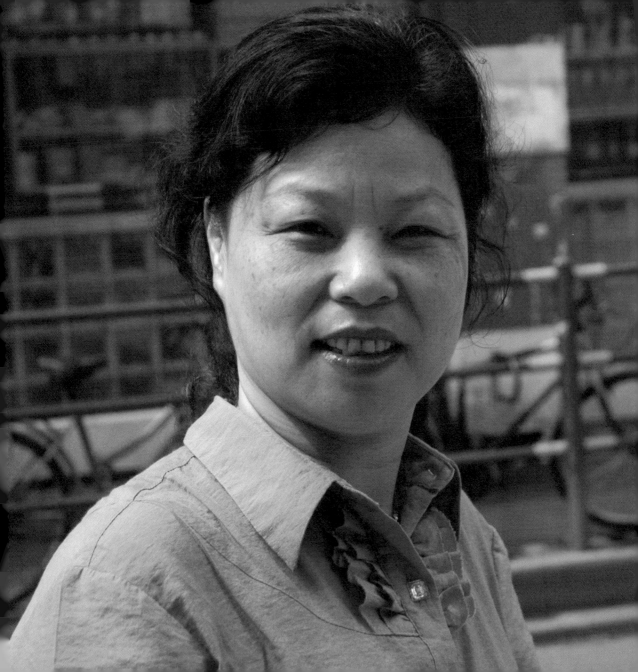

I am a factory owner. We make motorcycle clothing and noodle and pickles. We send this clothing to England. I have a lot of contact with foreigners but I don't speak English. I can read a little bit. Other people help me translate and communicate.

I don't have an English name. I don't like it. It is not that it doesn't sound nice but I am Chinese and I like my own name. It has a lot of meaning and my parents chose this name for me, Pei Lin. It sounds nice.

If foreigners send me an email they use Pei Lin. My Italian client studied Chinese in Beijing. My clients don't have trouble communicating and using my Chinese name.

A lot of young people have an English name. If they work at an office and have a lot of contact with foreigners they have an English name. I cannot remember their names. If they are not close related I don't know who's the person behind the name. I am a Chinese and I communicate here. I think youngsters often don't like their English name but they don't have a choice. Foreigners cannot remember their Chinese name.

My child hasn't got an English name yet. He is 18-years-old. When he goes to university he may choose one.

English names don't have meaning. People use English names but it won't change the Chinese culture because we still have our Chinese name. Only few people use English names. Every family has a special family registration book called *Hu Kou Ben*. You write all the family members in it, when they are born etc. one page per person. There are no foreign names in it. Not in any document.

In the factory people don't have English names. At the office young people normally do because they talk to foreigners.

I have a partner. We also make noodles. These noodles don't have an English name because we only sell nationally. Our clients are Chinese. It therefore doesn't need an English name.

I am now 48. When I was 20 and graduated I went to a factory that made clothing. At that time there were no foreigners in the country. After middle school graduation we didn't have university. The government chose what kind of work you should do. You couldn't choose yourself. I didn't like it but I had no choice. Knitting clothing etc. for 27 years I did this work. Twenty years in the factory and seven as the manager. After 20 years the government factory closed.

I afterwards opened my own clothing factory. As I worked in clothing for 20 years I had experience. If there is no connection with the government you cannot open a company.

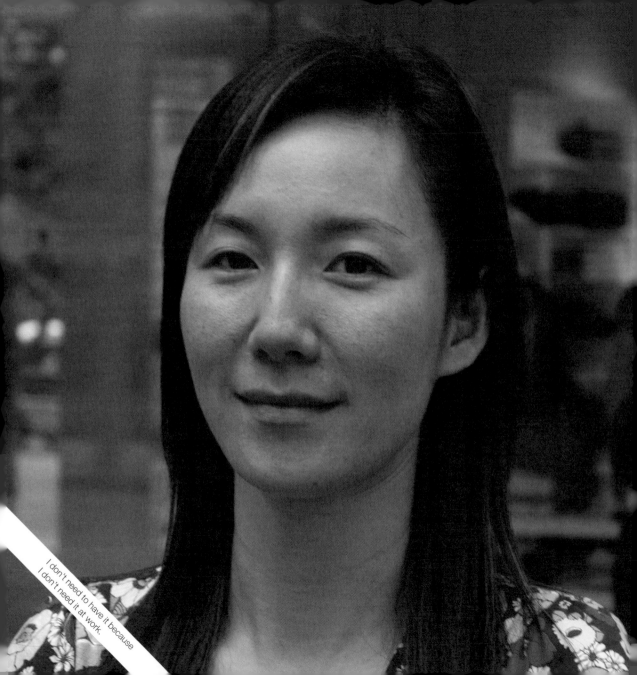

I don't need to have it because
I don't need it at work.

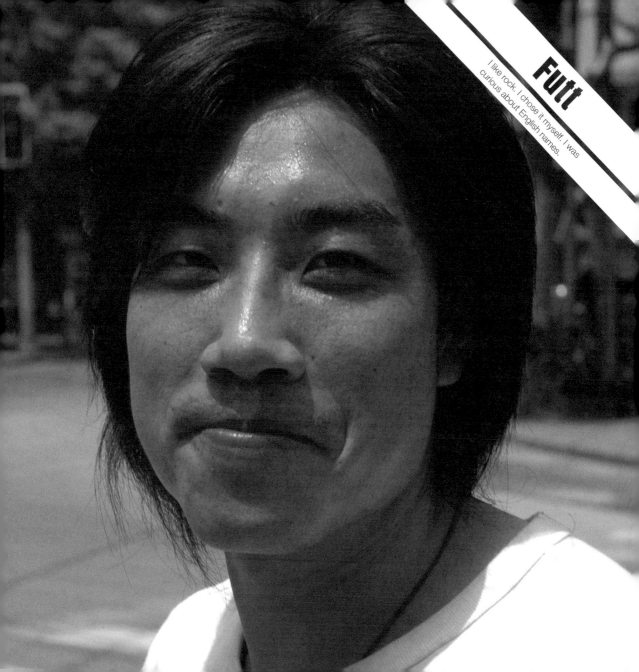

Futt

I like rock. I chose it myself. I was curious about English names.

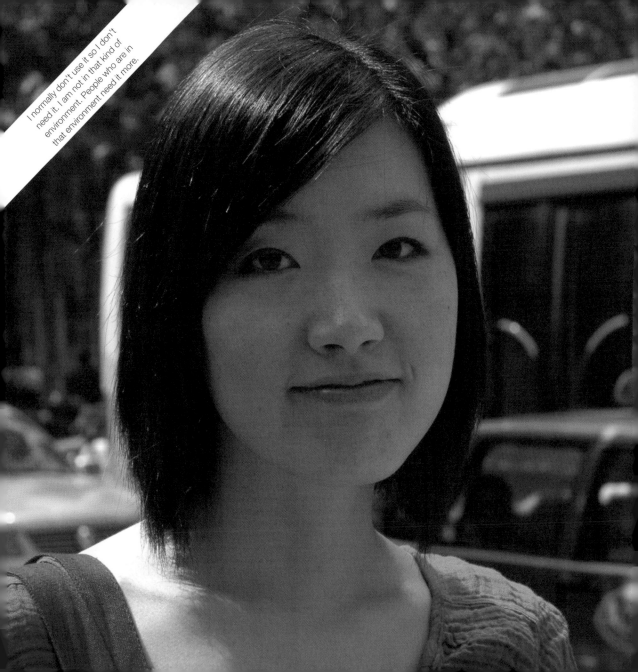

I normally don't use it so I don't need it. I am not in that kind of environment. People who are in that environment need it more.

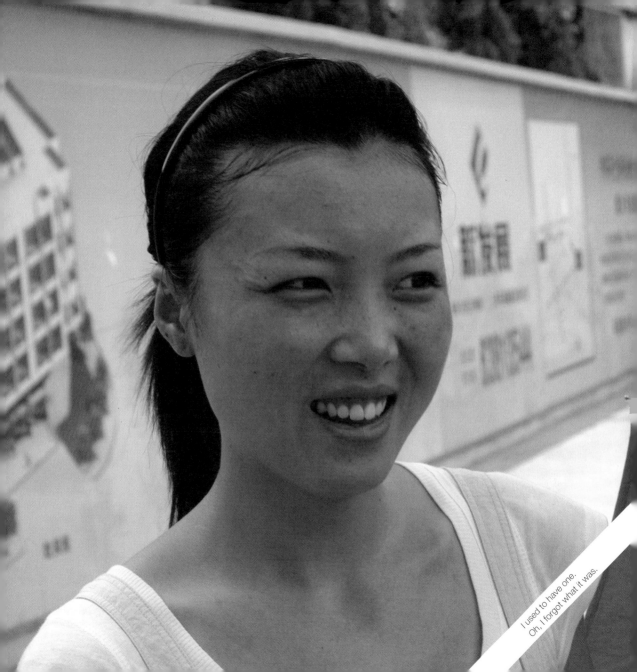

I used to have one.
Oh, I forgot what it was.

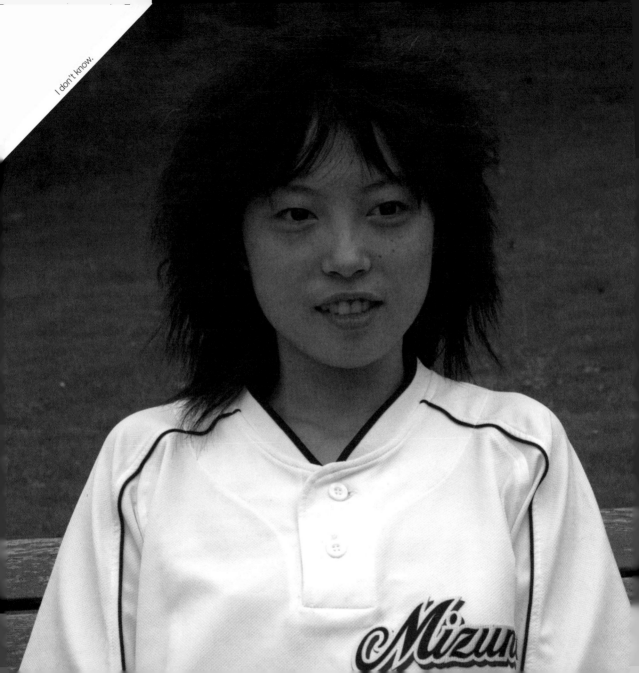

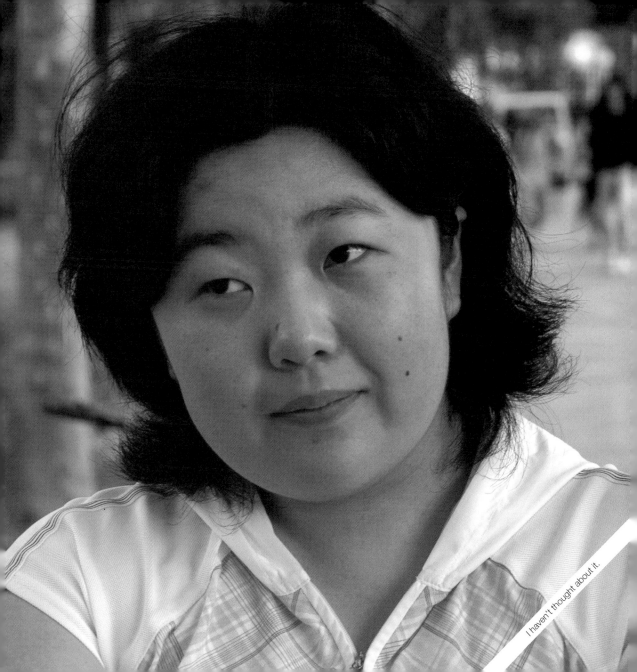

I haven't thought about it.

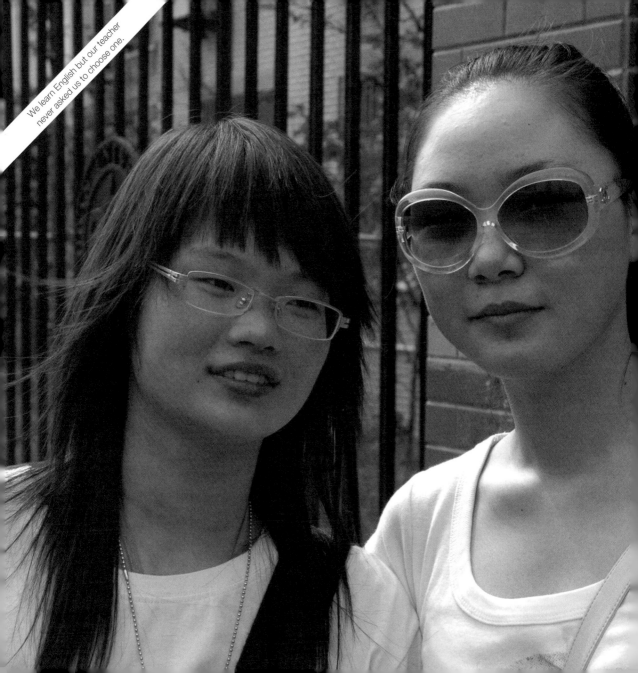

We learn English but our teacher never asked us to choose one.

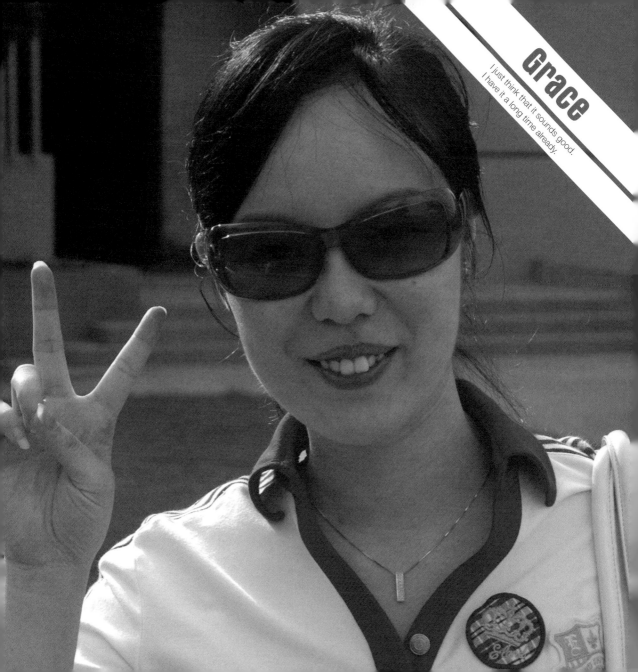

Grace
I just think that it sounds good.
I have it a long time already.

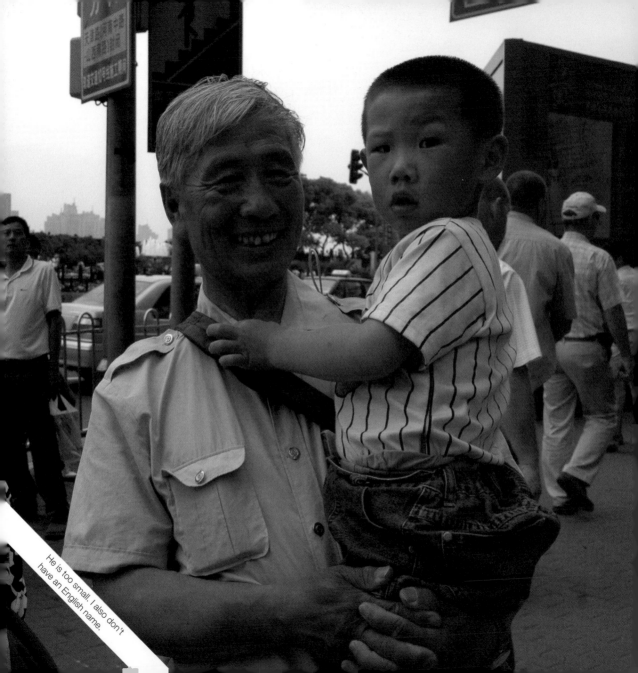

He is too small. I also don't have an English name.

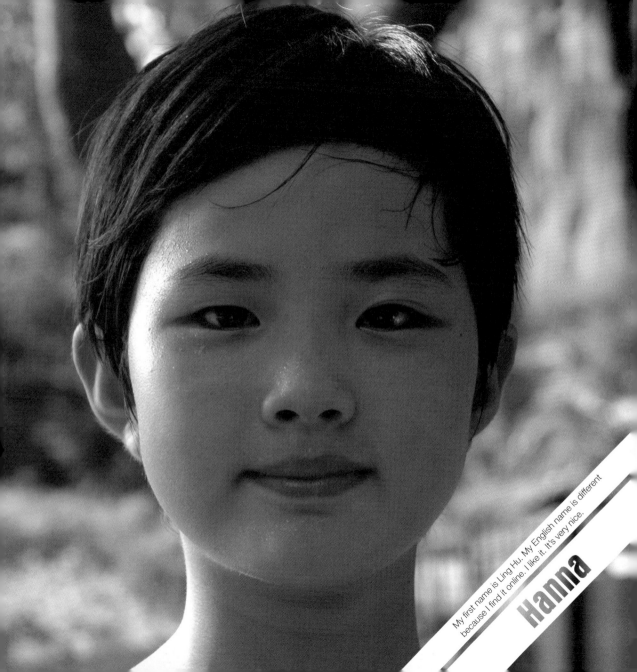

My first name is Ling Hu. My English name is different because I find it online. I like it. It's very nice.

Hanna

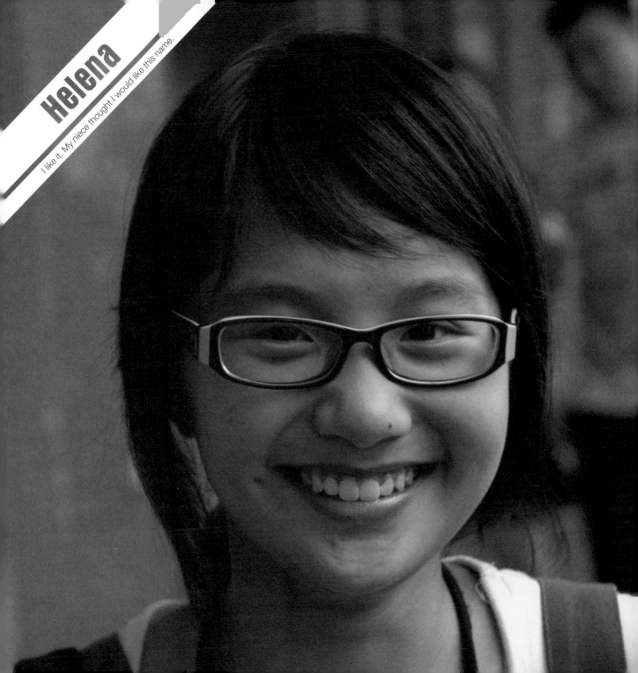

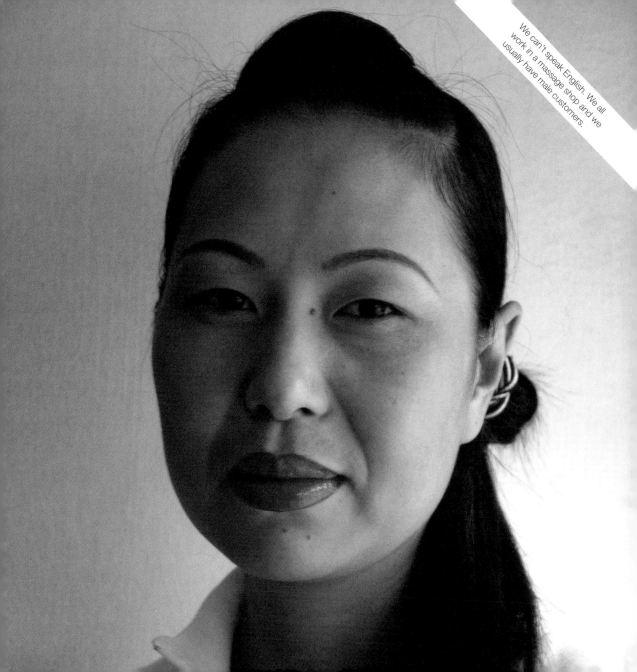

We can't speak English. We all work in a massage shop and we usually have male customers.

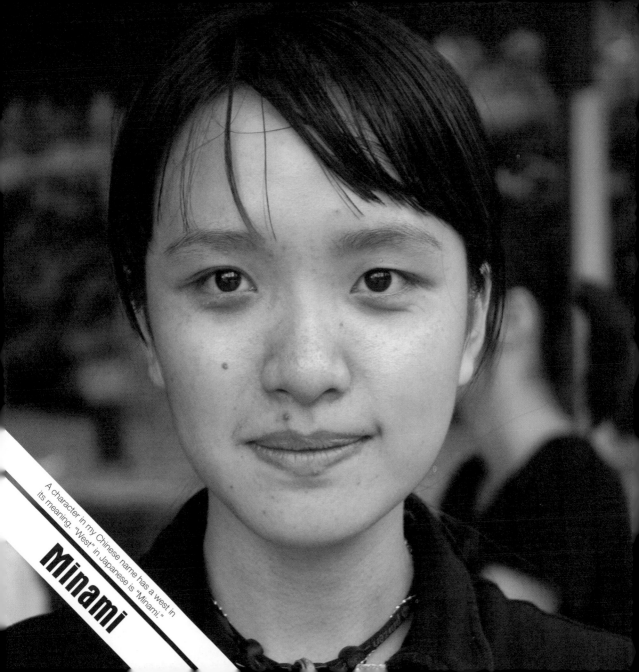

A character in my Chinese name has a west in its meaning. "West" in Japanese is "Minami."

Minami

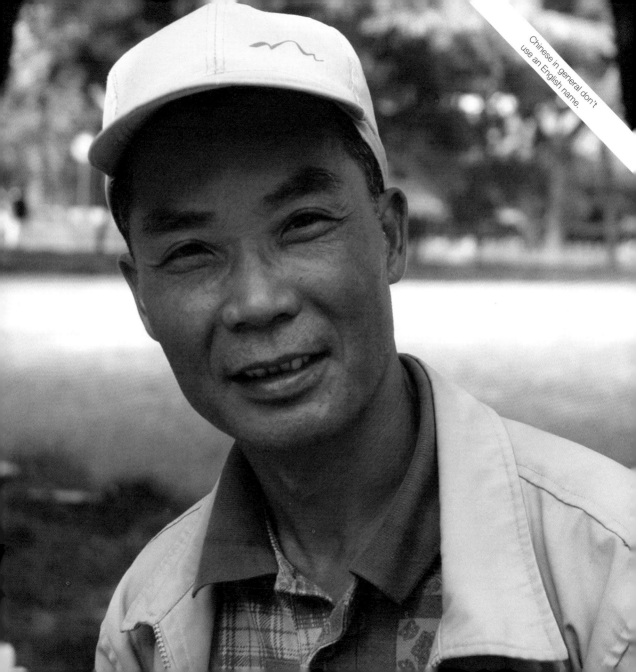

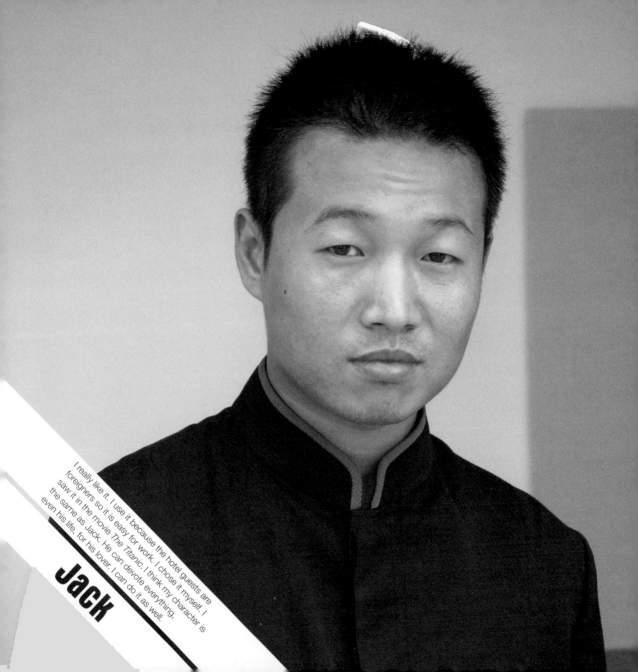

I really like it. I use it because the hotel guests are foreigners so it is easy for work. I chose it myself. I saw it in the movie The Titanic. I think my character is the same as Jack. He can devote everything, even his life, for his lover. I can do it as well.

Jack

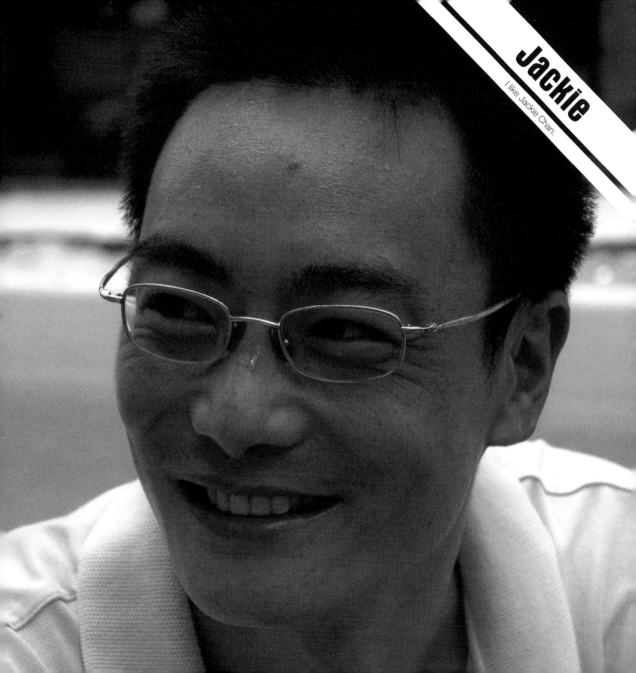

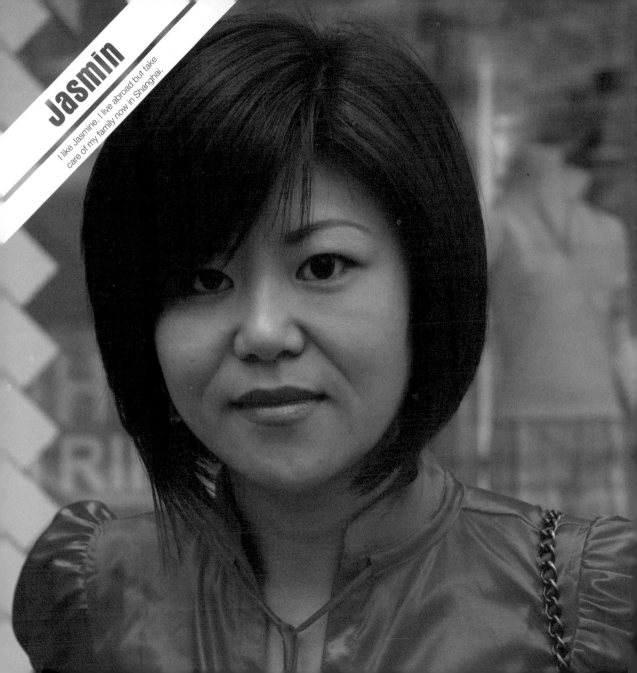

Jasmin

I like Jasmine. I live abroad but take care of my family now in Shanghai.

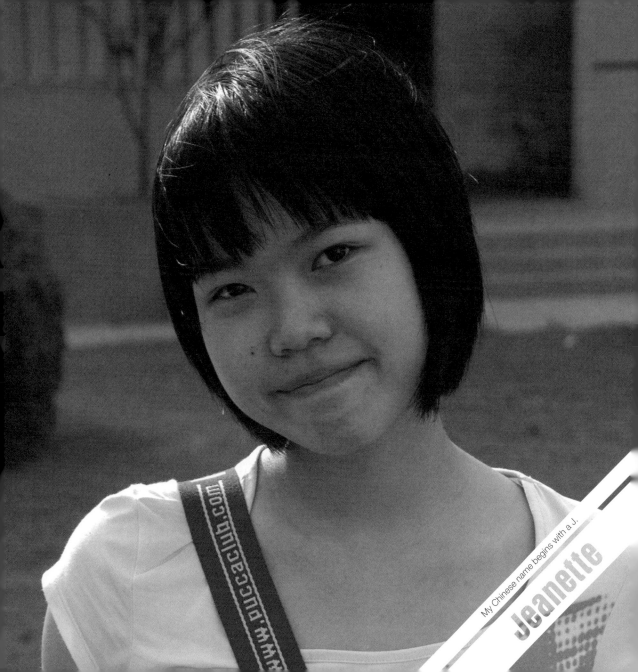

My Chinese name begins with a J.

Jeanette

www.puccaclub.com

Jelly (left): There are a lot of foreign companies. For the people that work inside these companies it is necessary to choose one. Amongst family and friends we use our Chinese name. You don't use it much so I don't think there is a bad influence on the Chinese culture. My Chinese name is Jiang Yan Li so it sounds similar and I like to eat jelly.

Kelly (right): My teacher helped me choose it in first grade and I use it until now. My Chinese name and English name have no connection. It's difficult to find similar names that are pronounced the same.

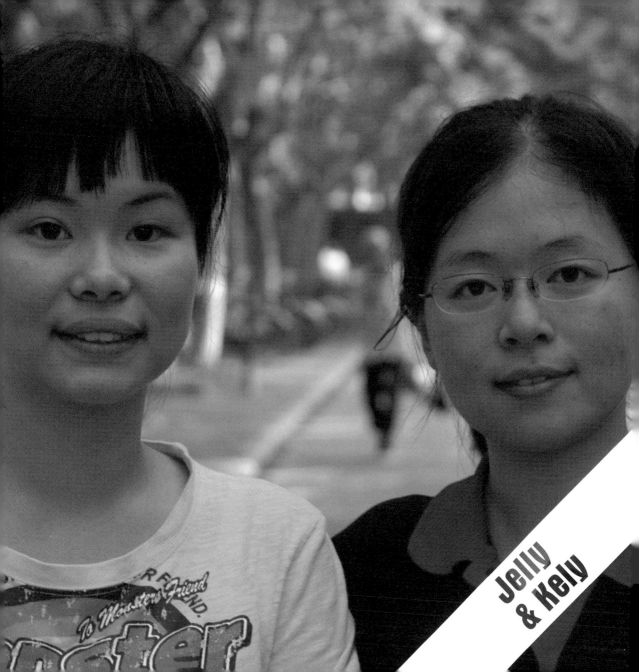

Jelly
& Kelly

Jenny

Karl Marx's daughter is called Ma Er Yan Ni in Chinese. Zhu Yan Ni is my Chinese name so it is similar. I don't use it often. A professor at the university gave it to me. Only friends from school call me Jenny. I think the name Jenny fits an open and young character. It doesn't fit my character.

It fits me. I work in a hotel so everyone must use it.

JESSICA

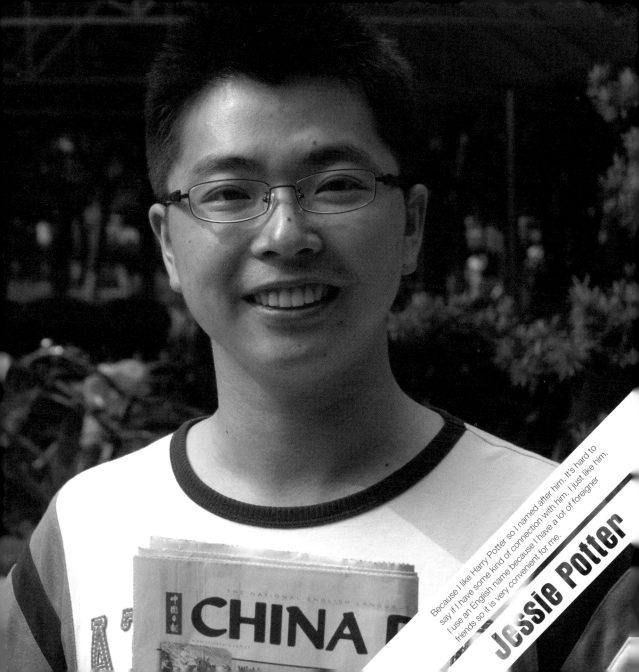

Because I like Harry Potter so I named after him. It's hard to say if I have some kind of connection with him. I just like him. I use an English name because I have a lot of foreigner friends so it is very convenient for me.

Jessie Potter

I chose before the revolution you see. I always speak
English. Don't hurt the mankind, we must love them.
When I was small I learned English. John: I am a
Christian you see.

Franklin: Franklin comes from Franklin Roosevelt and
Franklin Anderson. I am very honored to them you
see. Yu: And third a person working on the moon:
Mr. Yu.

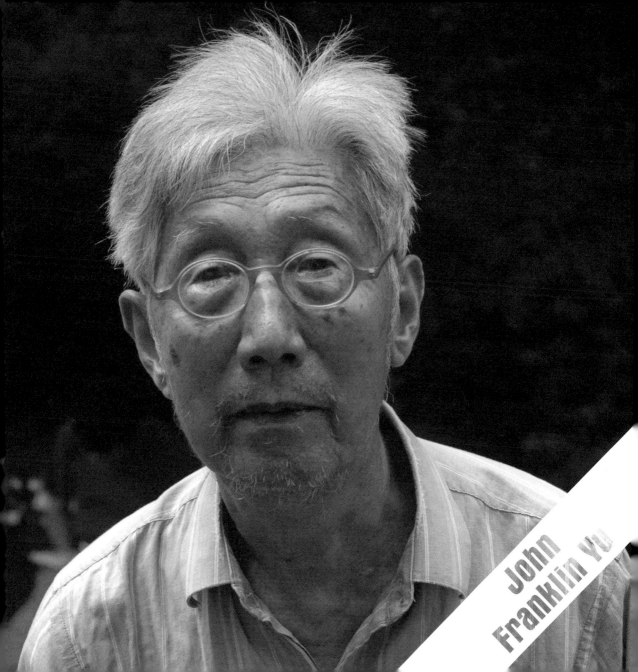

John
Franklin Yu

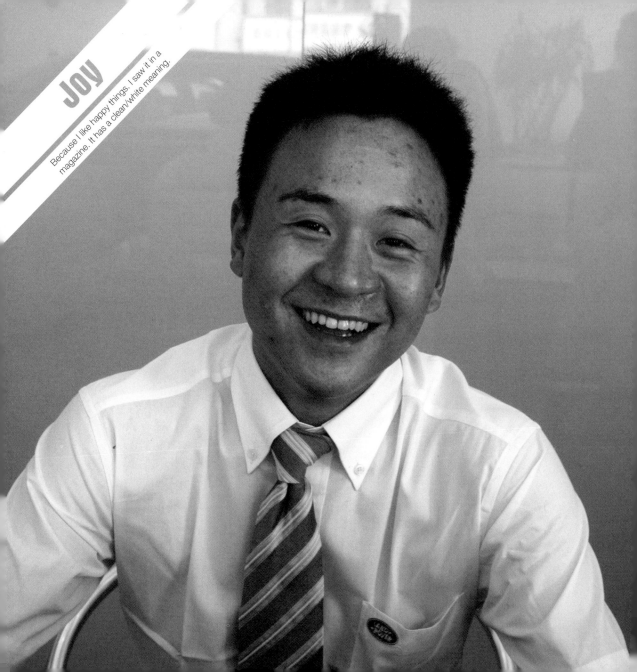

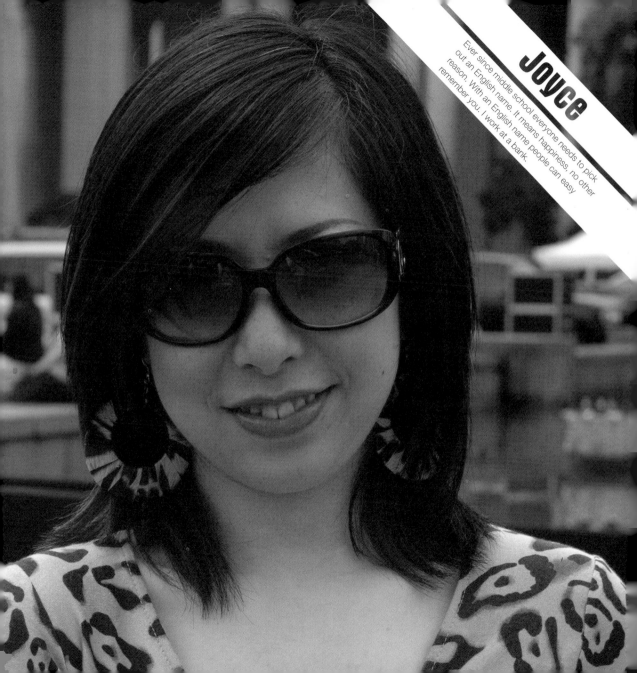

Joyce

Ever since middle school everyone needs to pick out an English name. It means happiness, no other reason. With an English name people can easy remember you. I work at a bank.

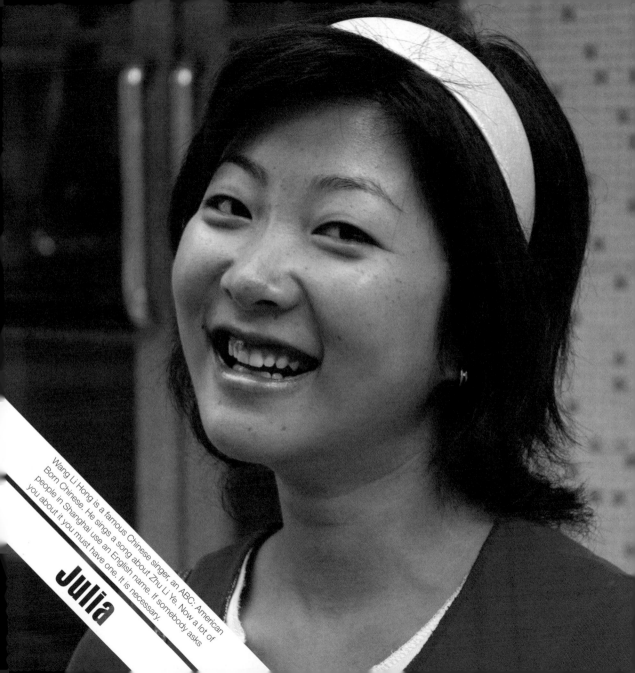

Wang Li Hong is a famous Chinese singer, an ABC: American Born Chinese. He sings a song about Zhu Li Ye. Now a lot of people in Shanghai use an English name. If somebody asks you about it you must have one. It is necessary.

Julia

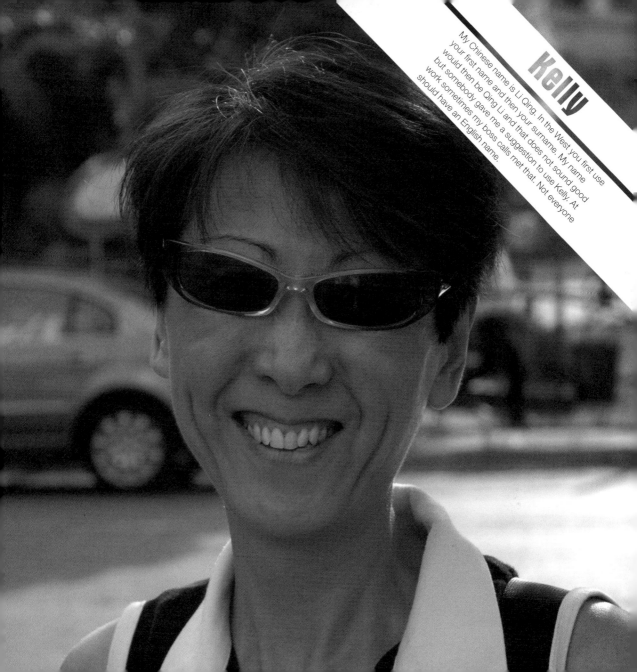

Kelly

My Chinese name is Li Qing. In the West you first use your first name and then your surname. My name would then be Qing Li and that does not sound good but somebody gave me a suggestion to use Kelly. At work sometimes my boss calls met that. Not everyone should have an English name.

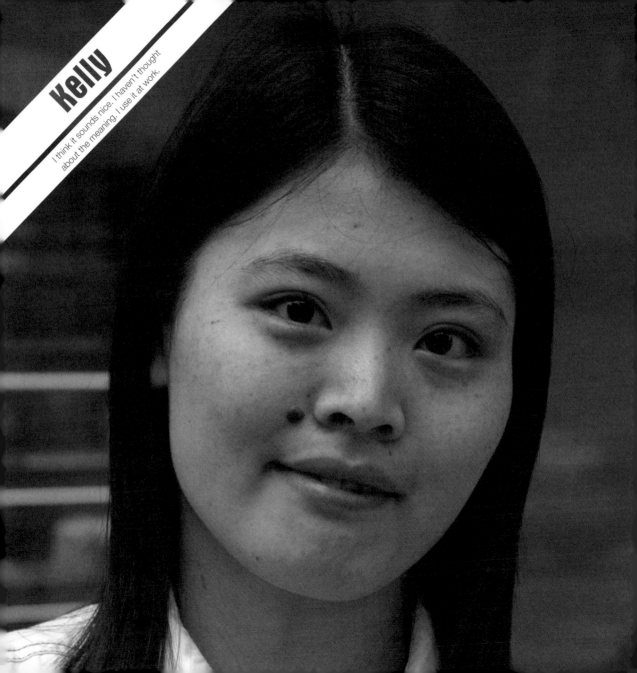

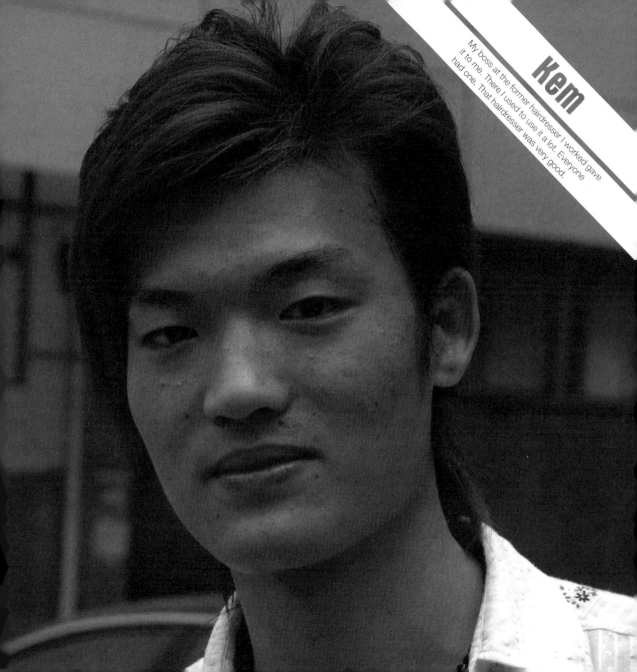

Kem

My boss at the former hairdresser I worked gave it to me. There I used to use it a lot. Everyone had one. That hairdresser was very good.

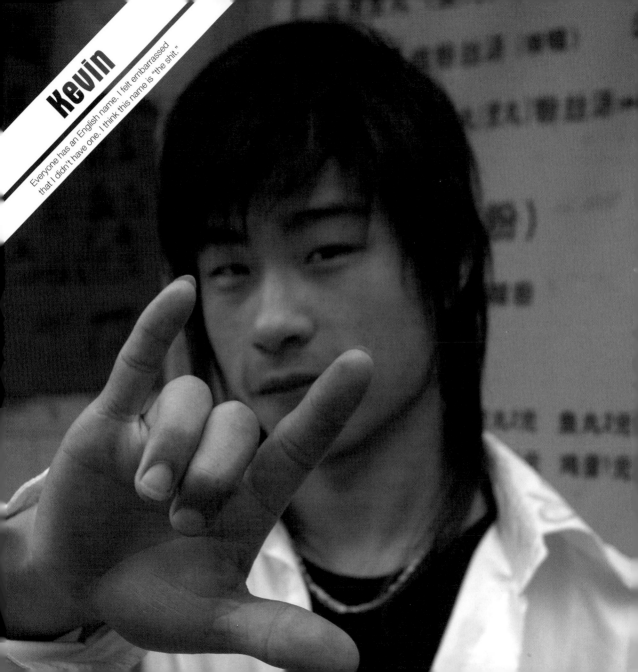

Kevin

Everyone has an English name. I felt embarrassed that I didn't have one. I think this name is "the shit."

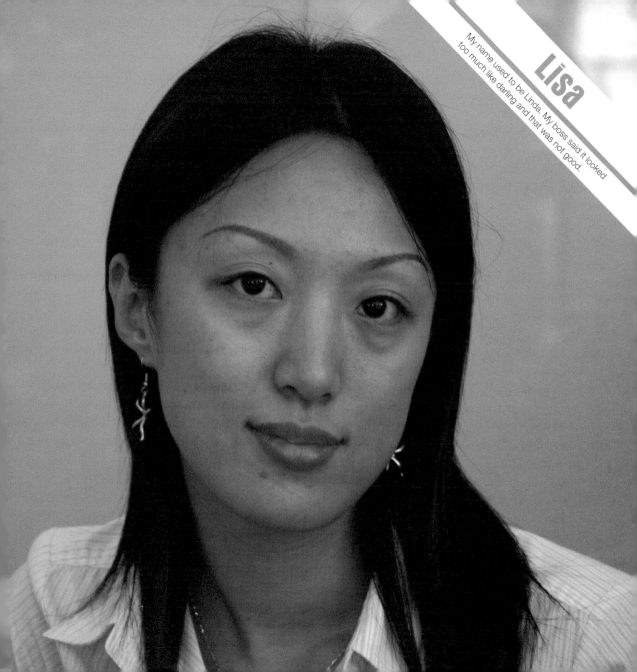

Lisa

My name used to be Linda. My boss said it looked too much like darling and that was not good.

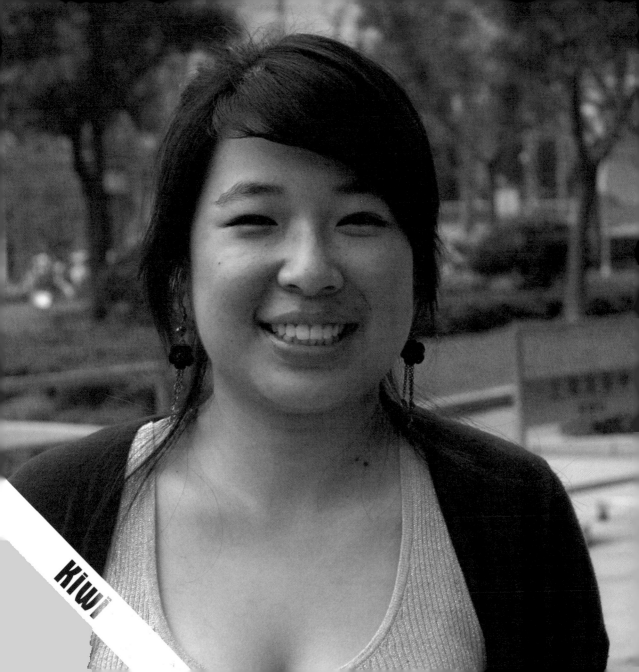

Kiwi

Because my Chinese name is Pi Ki. This sounds very similar to "kiwi" in Chinese *piguo*. So that is why I chose it. We were asked to choose an English name before joining the company. I don't see the necessity of choosing an English name. My friends all call me by my Chinese name or use a nickname but that is also in Chinese. It is difficult to choose one. There are so many English names. You want it to be special, interesting, funny and easy to remember. I told my foreign friends I can change my English name every time I want. They said "Wow."

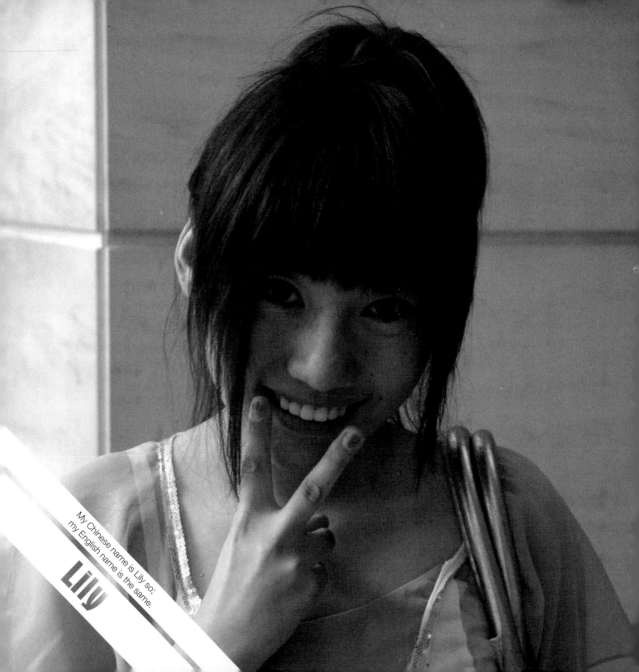

My Chinese name is Lily so;
my English name is the same.

Lily

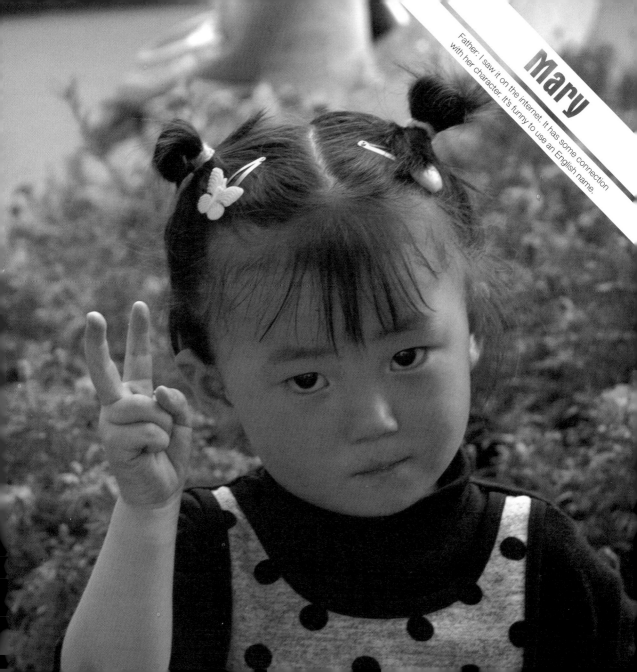

Mary

Father: I saw it on the internet. It has some connection with her character. It's funny to use an English name.

In '98/'99 there was a popular video game. You needed to choose an ID. At first I chose Link. A lot of people already had this name so I changed it into link4338. When I learned English in university you needed to choose an English name. I liked Link but it is a verb, so it is not so good. I therefore added a "y" at the end. I also liked the name Jackson so I decided to place "son" after Linky, Linkyson. My teacher often called me in the class and he thought it was strange. I also thought so.

After graduation I went to work at a foreign company. There I also needed to choose an English name. I distracted "son" so now it is Linky. Nobody in this company has this name so it is very special.

It is actually also a connection with the work I do inside a shipping company. This name is quite good.

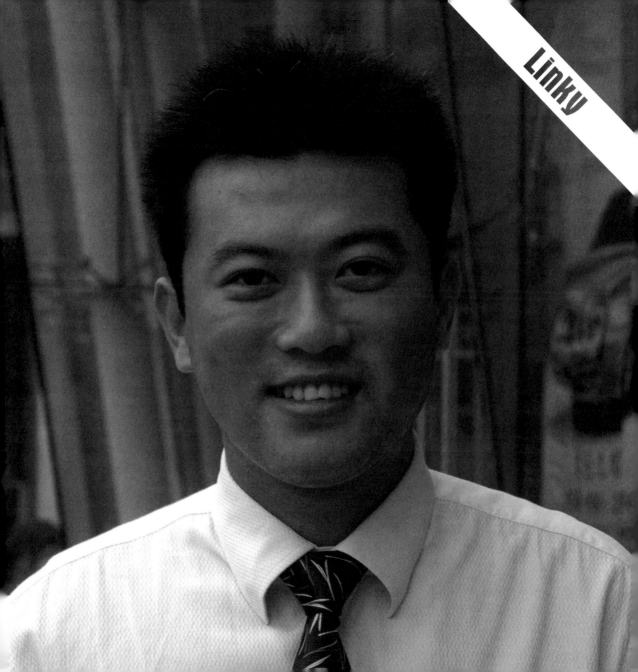

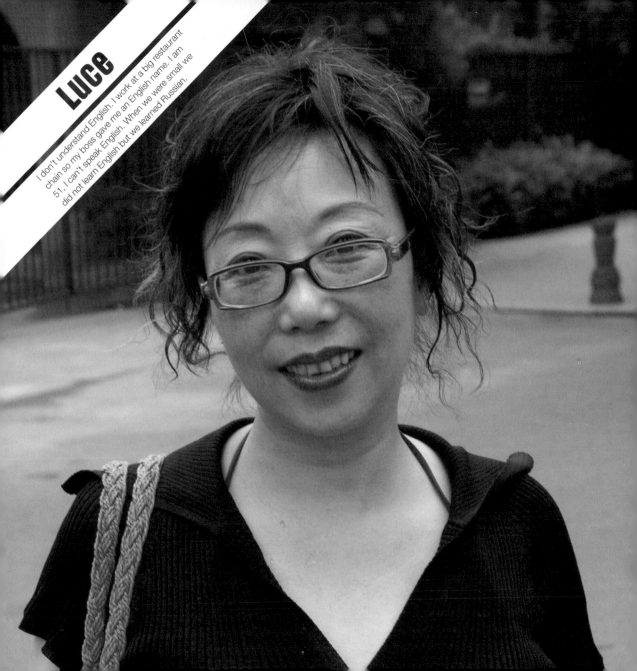

I don't understand English, I work at a big restaurant chain so my boss gave me an English name. I am 51. I can't speak English. When we were small we did not learn English but we learned Russian.

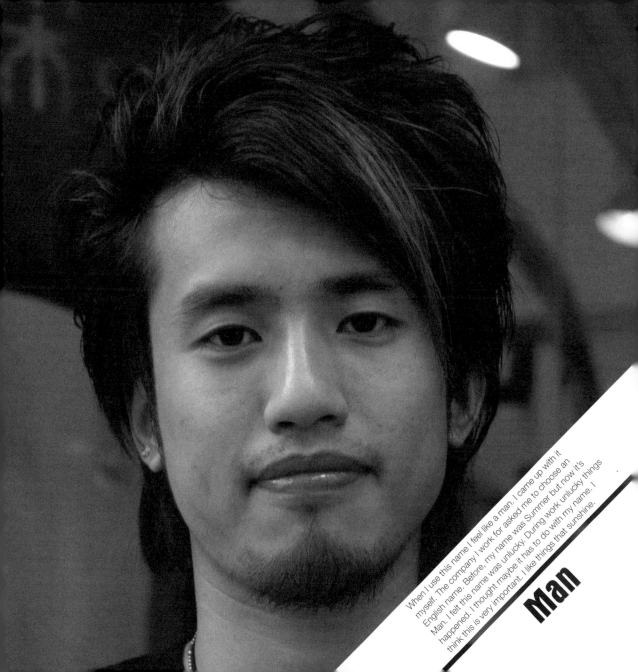

When I use this name I feel like a man. I came up with it myself. The company I work for asked me to choose an English name. Before, my name was Summer but now it's Man. I felt this name was unlucky. During work unlucky things happened. I thought maybe it has to do with my name. I think this is very important. I like things that sunshine.

Man

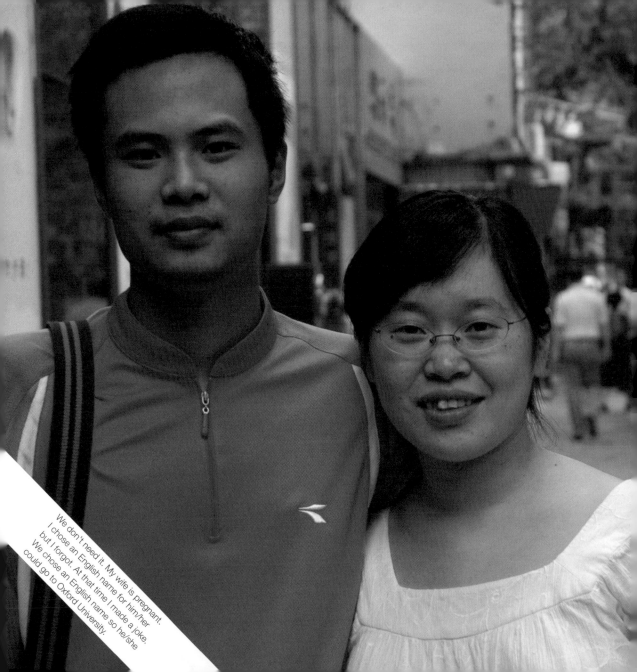

We don't need it. My wife is pregnant.
I chose an English name for him/her
but I forgot. At that time I made a joke.
We chose an English name so he/she
could go to Oxford University.

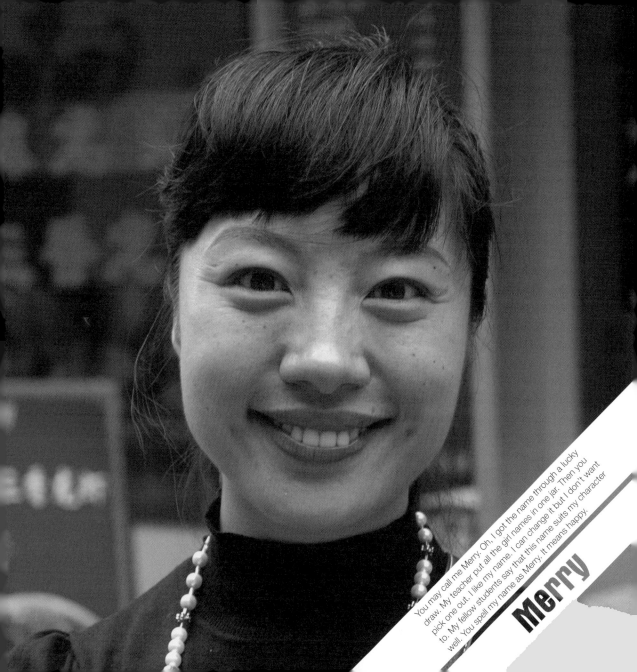

You may call me Merry. Oh, I got the name through a lucky draw. My teacher put all the girl names in one jar. Then you pick one out. I like my name. I can change it but I don't want to. My fellow students say that this name suits my character well. You spell my name as Merry. It means happy.

Merry

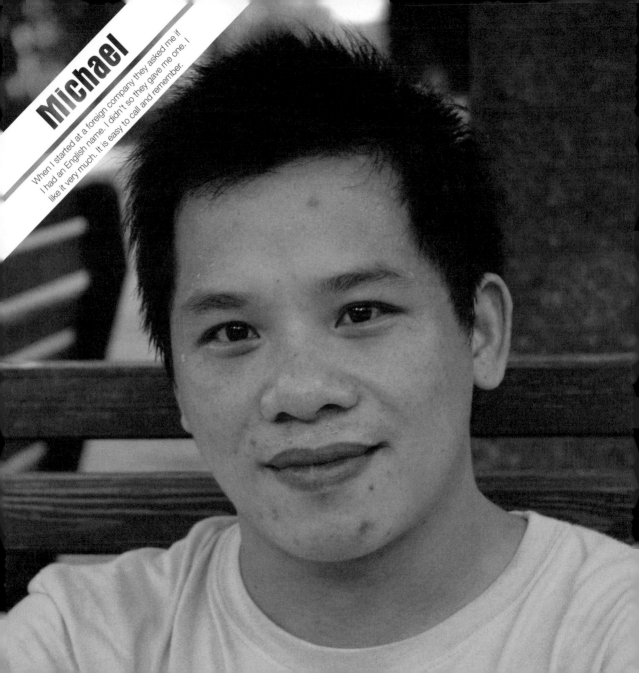

Michael

When I started at a foreign company they asked me if I had an English name. I didn't so they gave me one. I like it very much. It is easy to call and remember. I

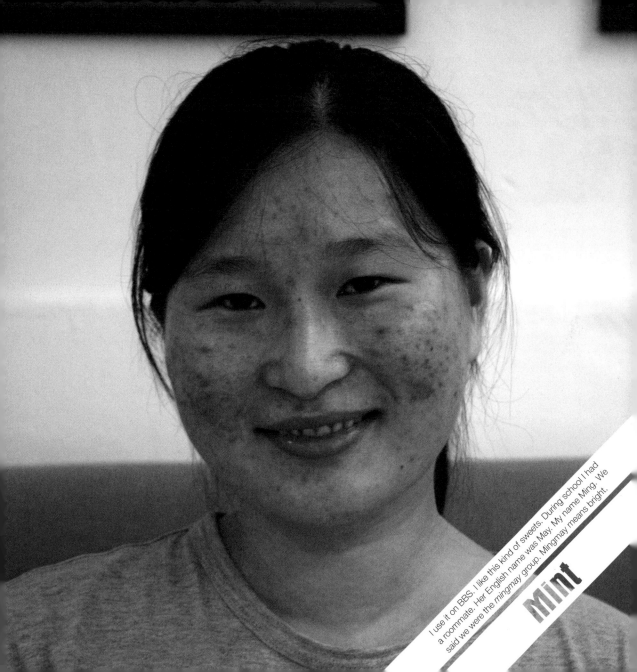

I use it on BBS. I like this kind of sweets. During school I had a roommate. Her English name was May. My name Ming. We said we were the *mingmay* group. Mingmay means bright.

Mint

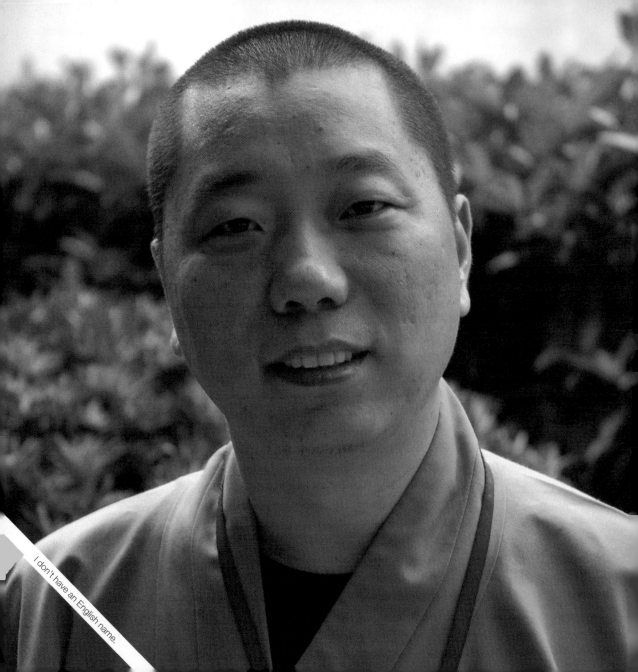

I don't have an English name.

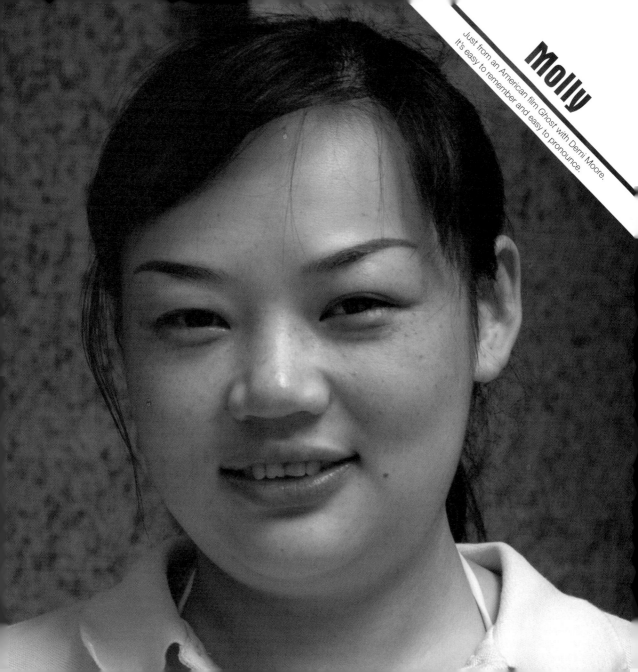

Molly

Just from an American film Ghost with Demi Moore. It's easy to remember and easy to pronounce.

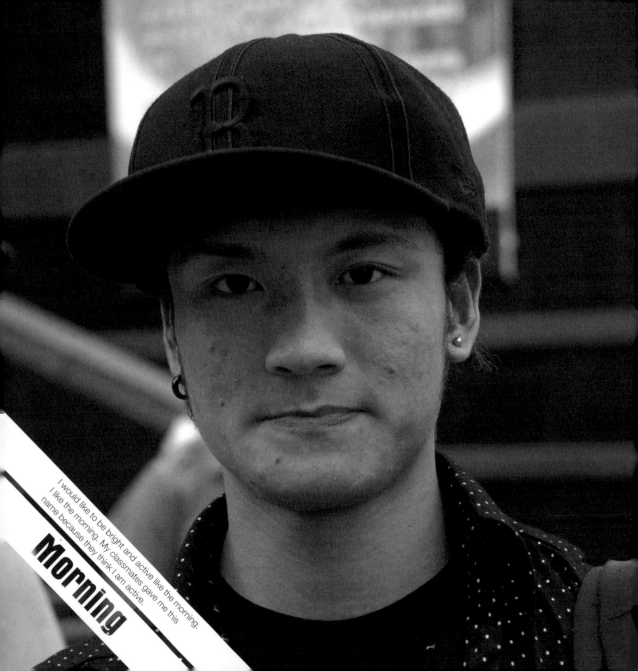

I would like to be bright and active like the morning.
I like the morning. My classmates gave me this
name because they think I am active.

Morning

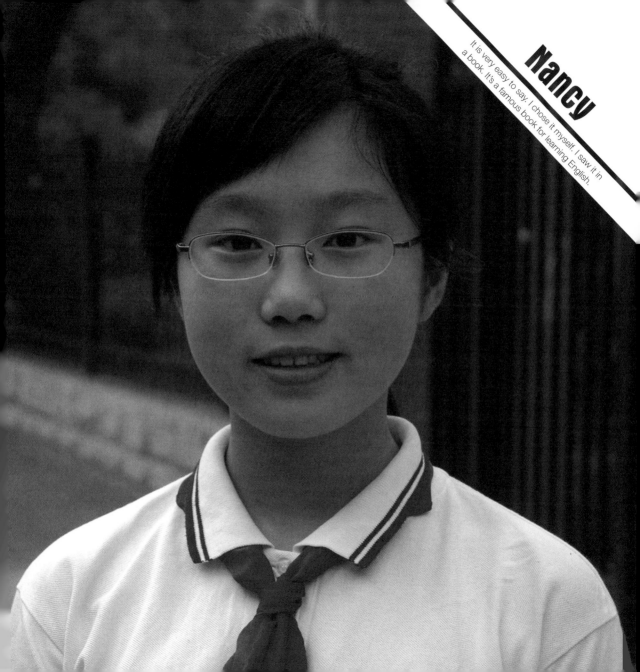

Nancy

It is very easy to say. I chose it myself. I saw it in a book. It's a famous book for learning English.

Nimo is a fish. This fish is clever. I am also quite clever. Haha. I think Nimo is involved and I am involved too. Nimo has no connection with my Chinese name. I just like the movie. Before the movie came out my name was Toni. Toni came from Toni & Guy, the famous American hairdresser. I work at a hairdresser and I use my English name at work. I am just graduated. First I want to gain experience and master hairdressing skills. Eventually I want to buy a house and continue my career.

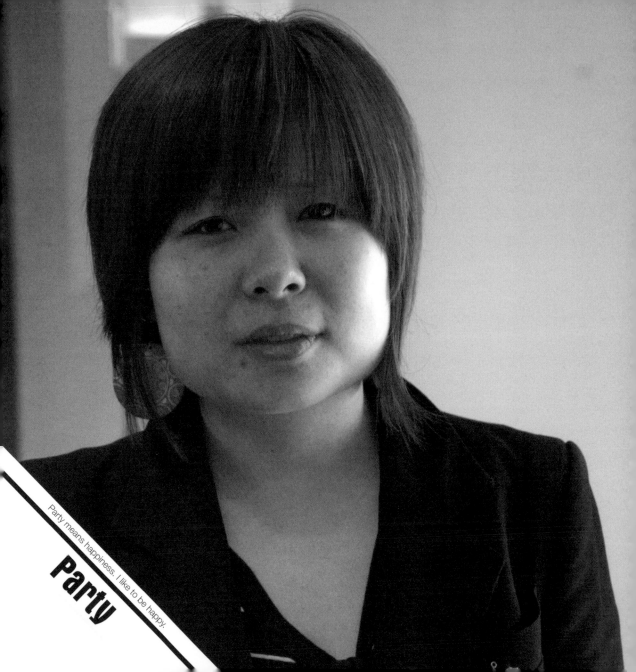

Party means happiness. I like to be happy.

Party

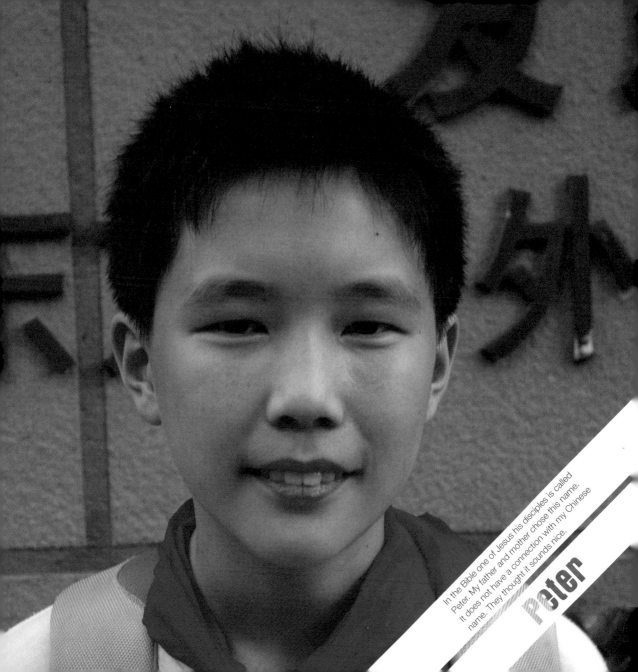

In the Bible one of Jesus his disciples is called Peter. My father and mother chose this name. It does not have a connection with my Chinese name. They thought it sounds nice.

Peter

You know it's a bird that never dies and a city in the USA is called Phoenix. It has a basketball team, Phoenix Suns. I like them very much. And I like the bird whose spirit never gives up anything. That's why I called Phoenix.

Zhang shi lei: stand by your son. It also means the spirit that never dies.

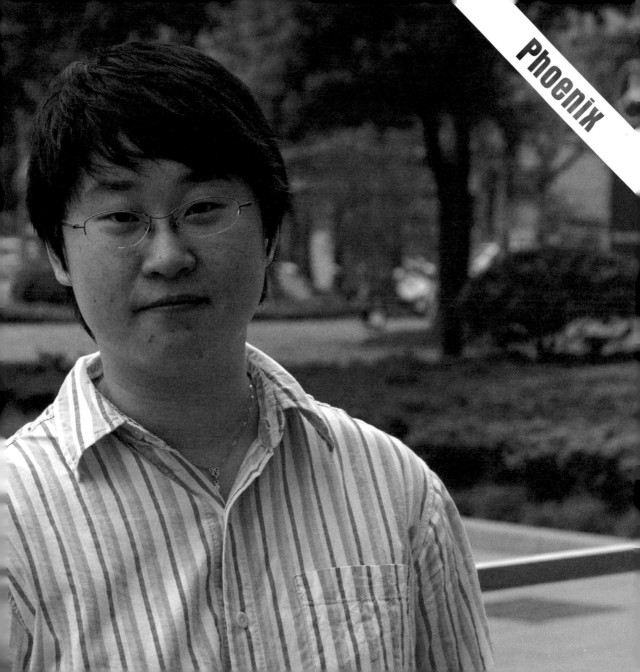
Phoenix

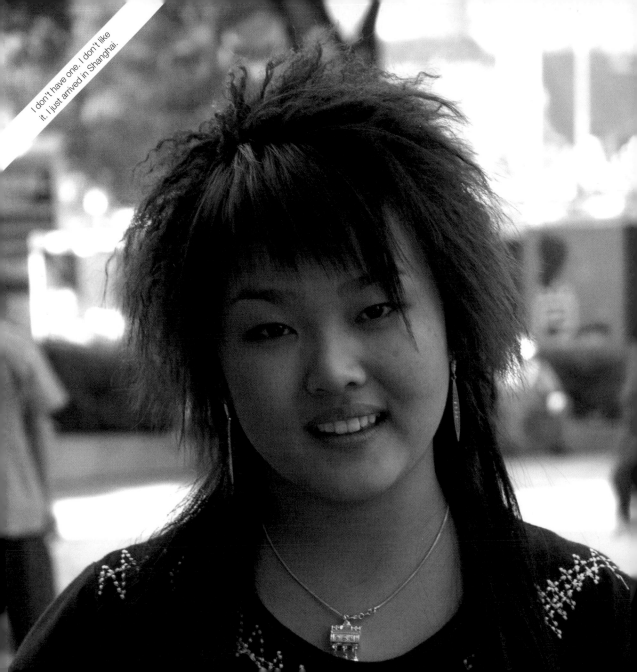

I don't have one. I don't like it. I just arrived in Shanghai.

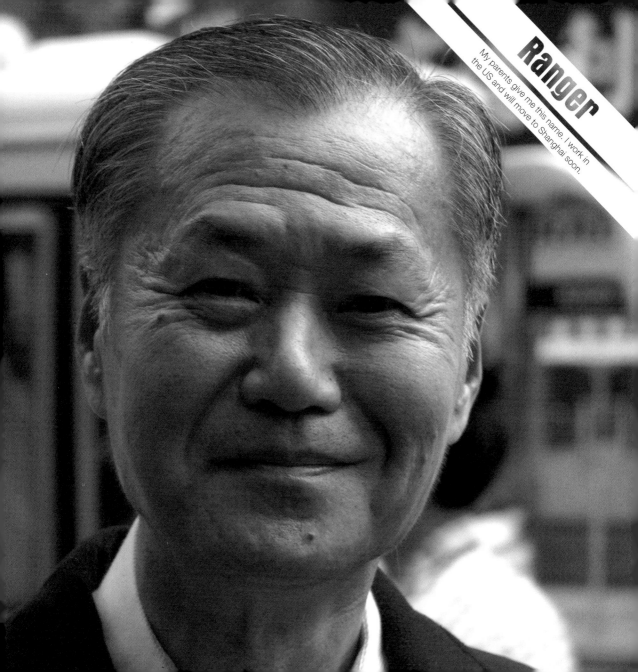

Ranger

My parents give me this name. I work in the US and will move to Shanghai soon.

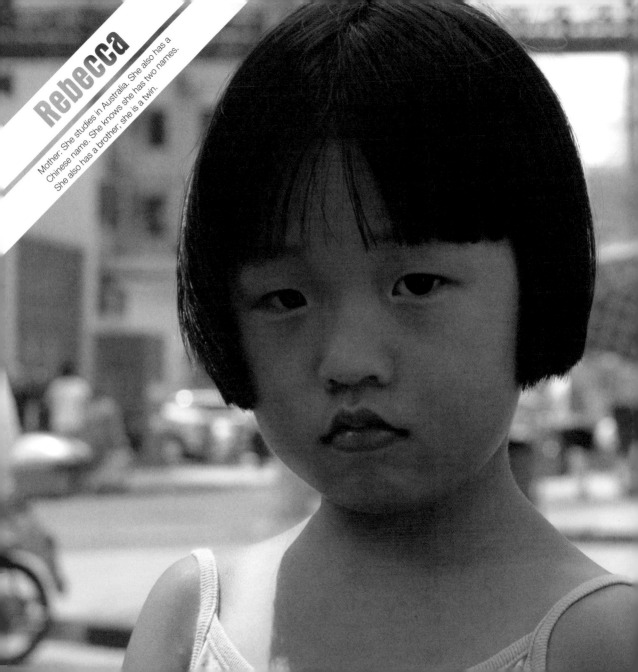

Rebecca

Mother: She studies in Australia. She also has a Chinese name. She knows she has two names. She also has a brother; she is a twin.

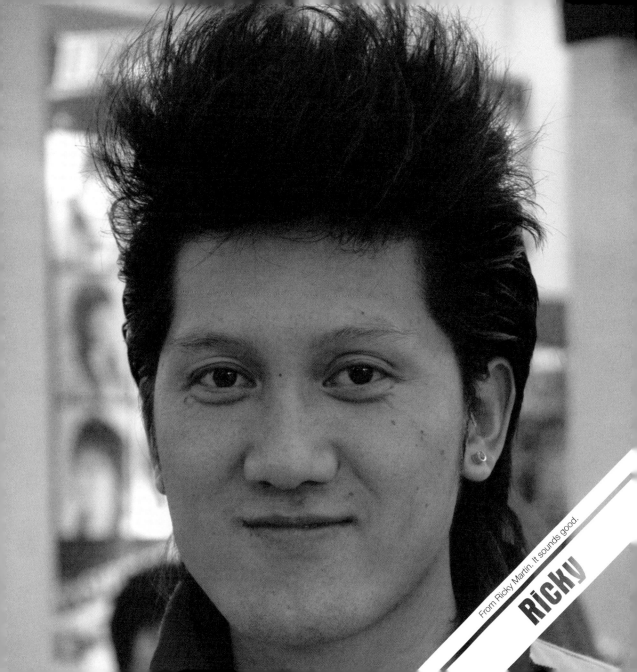

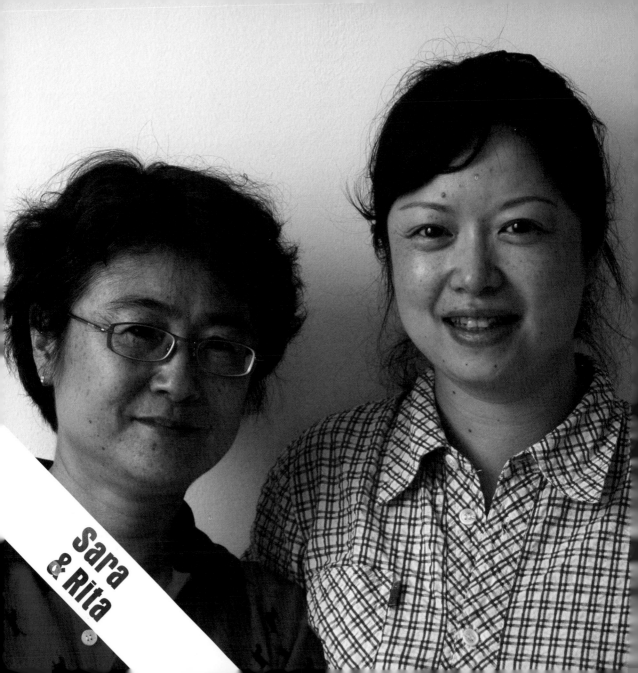

Sara & Rita

Sara (left): Some students already have an English name. When they don't have an English name we help them choose one. It is an easy way to have an English name. When some foreign or westerner teacher come usually they prefer English names for all their students because that will be easy for them to keep in mind and since the pronunciation of Chinese is so complicated. This is also a common way for the students to arouse their interest in English. This is also kind of fun. For some naughty boys maybe they don't want a second name besides their name of their father but that's OK because western teacher also nowadays more and more show their interest in Chinese. I think you can even find some boys and girls working in the office they have both names. It is becoming more common.

Rita (right): Some young people like some actress or actor and so they choose their name.

Sara: They don't want other to know their real name. It is a modern way to put their name on the internet.

Rita: I like one of the American actresses, Rita Hayworth. I think she was very beautiful. I like her so I chose her name.

Sara: The pronunciation is a little bit similar to my Chinese name and also I think it has good meaning. Sara was in history a famous woman. I give it to myself and also I think my parents think it is also a good name. I have this name for a lot of years. So my French friends, American friends or close friends always call this name.

Chinese name it is from their parents or ancestor, follow the family tree. Zheng Xia Yo or Zheng Xiao Hua. Chinese name have another way.

Some students don't know the meaning of their English names and they are naughty to try to invent some very strange words as their names and as an English teacher usually we can stop them to correct or have a better one but off course you should let them agree with the teachers idea.

When we English teacher know some stories behind the English name off course we would like to tell them. More and more girls want to be unique. For example "Mary," i t is so common. You don't want to have the same name.

Rita: You want to be different.

Sara: When we use our dictionary sometimes you want to get some better and more interesting one and have a few three or four let the students to choose which you prefer.

I find the name from the book or a famous person. It is not easy to find a similar name connected to Chinese.

Rita: I can give an example. One of my colleagues is Ding Jie Ming so she chose her nickname, Jasmin. It sounds similar. Another: my colleague is called Cheng An Ni. She is called Annie.

Sara: It is easy to keep in mind. Try to find a little bit connection between the two names also interesting and meaningful.

Traditional Chinese parents don't try but if your parents once studied in a university major subject is about western literature or culture they might.

My mother, she is very old. Once her major subject is English literature. Her English name is Sophia and since her Chinese name is Su Shen. It is similar. She talked to me about my English name. She helped me choose one. She was also an English teacher. We both are interested in English.

Ruby: My name is Ruby. It is a lucky stone. I work for a foreign company so I need an English name. It's easy. I am pregnant. We are thinking of naming our son Michael but we don't know if it is ok. All the Micheal's we know are good. We like Michael Jordan and Michael Schumacher. He will go to school in the future. There they will have to choose an English name. We want to choose one instead of the teacher. It has more meaning.

Jason: I also use it at work.

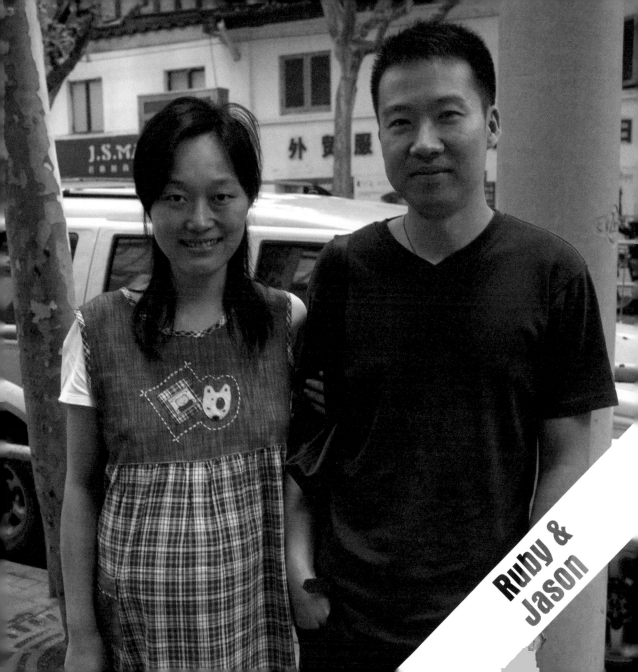

Ruby &
Jason

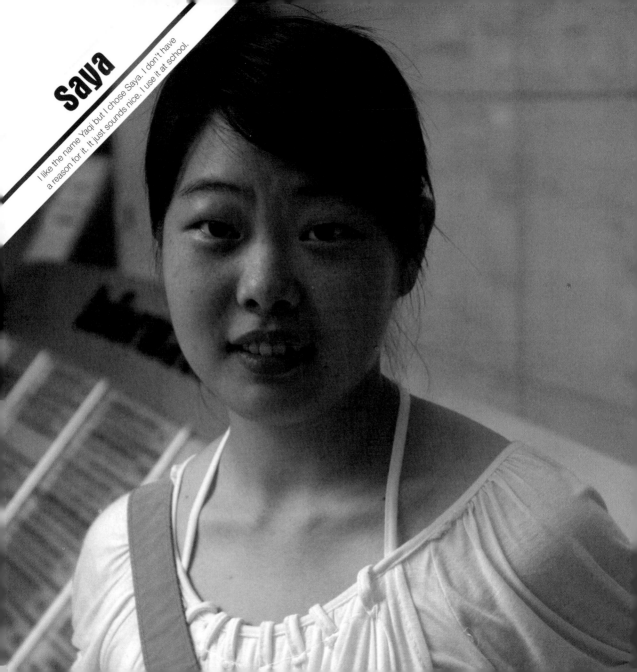

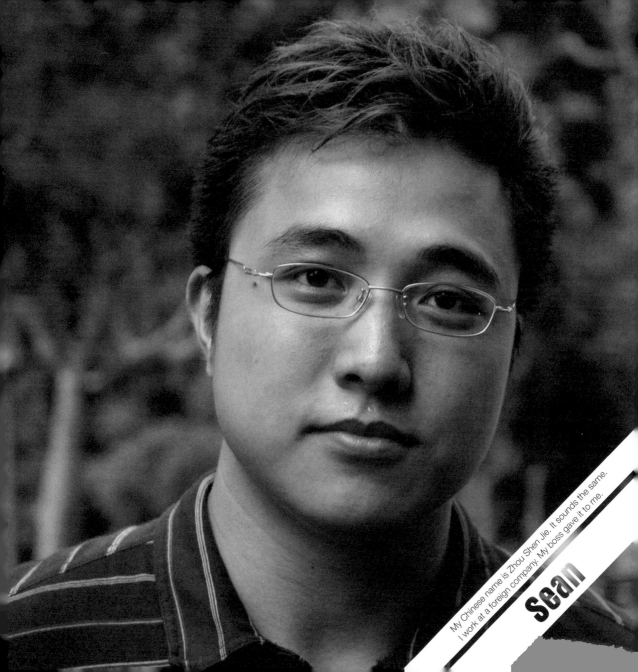

My Chinese name is Zhou Shen Jie. It sounds the same.
I work at a foreign company. My boss gave it to me.

Sean

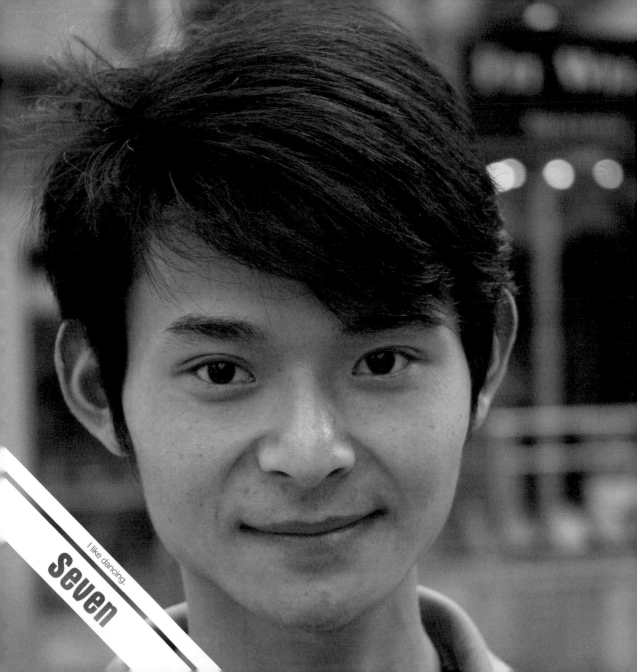

I like dancing.

Seven

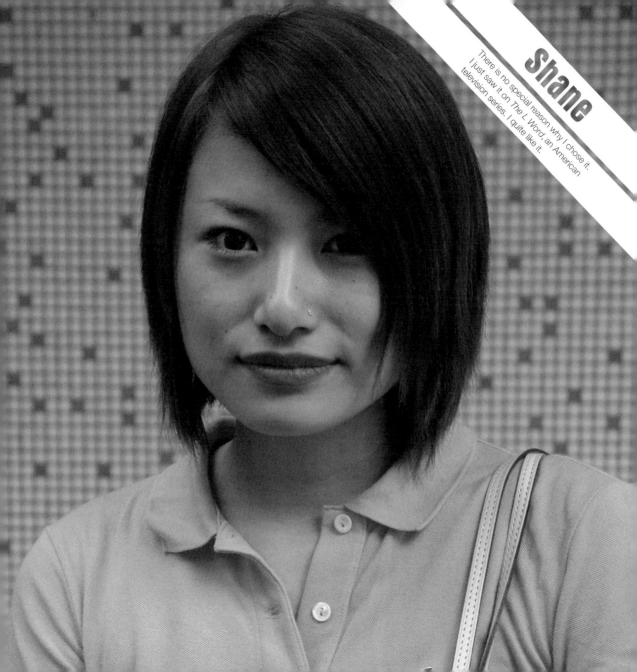

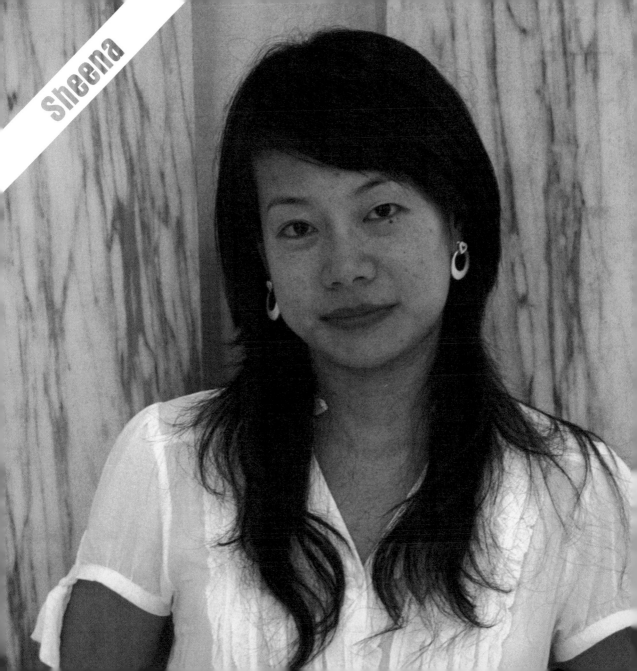

So every one think I chose this name because I love Ramones because one of their most famous songs called "Sheena is a Punk Rocker." Actually I chose this name from another female singer she is Sheena Easton which I had it long long ago. She is one of my favorite female singers when I was a child. Also this one is seldom used among Chinese. After I learned a little bit French I found out that Sheena's pronunciation is a little bit similar to China in French; that would be perfect.

I'm from Shanghai. My English teacher asked me to choose an English name. Now I use my name for my foreign friends and when I am working for *Hit Magazine*. I have to interview foreign artists. My family and Chinese friends are calling me with my Chinese name or nickname. My English name has no connection with my Chinese name.

I'm lead singer of the band Hard Queen. We call our music "basement in the rock." We actually wanted another name for our band: Hard Candy. It's from a nice movie. But we discovered that a Hong Kong band already took this name. The name Hard Queen is hard and lovely at the same time. Our music rocks.

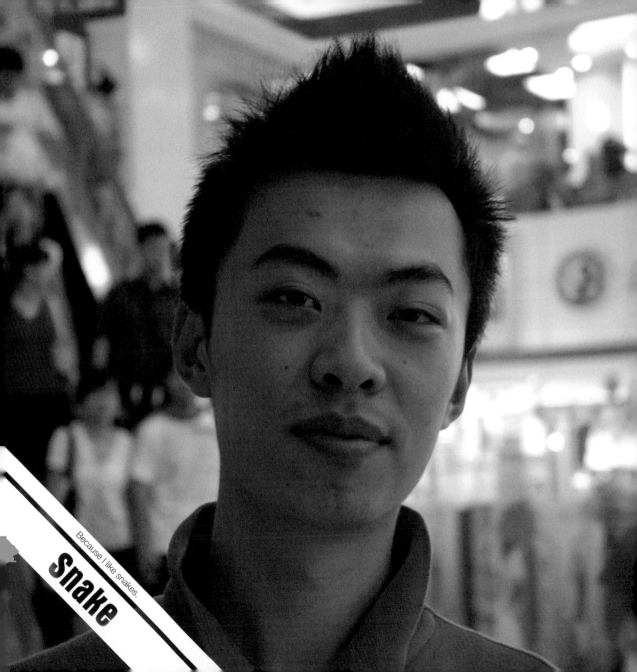

Snake

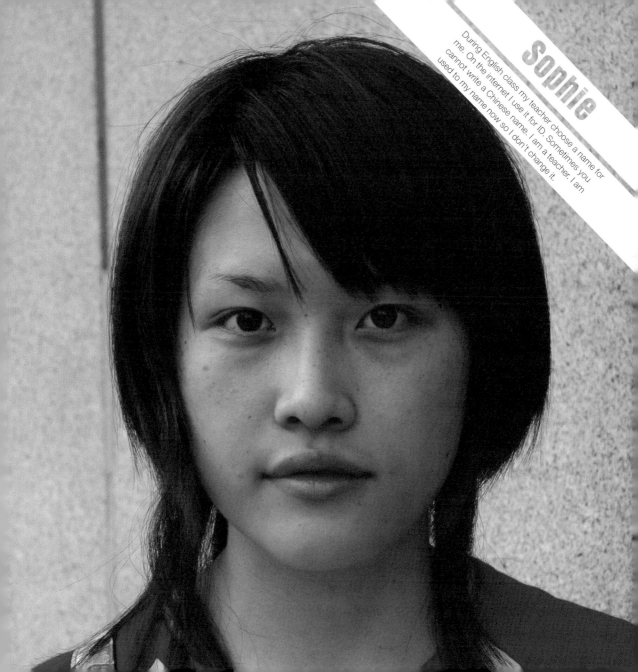

Sophie

During English class my teacher choose a name for me. On the internet I use it for ID. Sometimes you cannot write a Chinese name. I am a teacher. I am used to my name now so I don't change it.

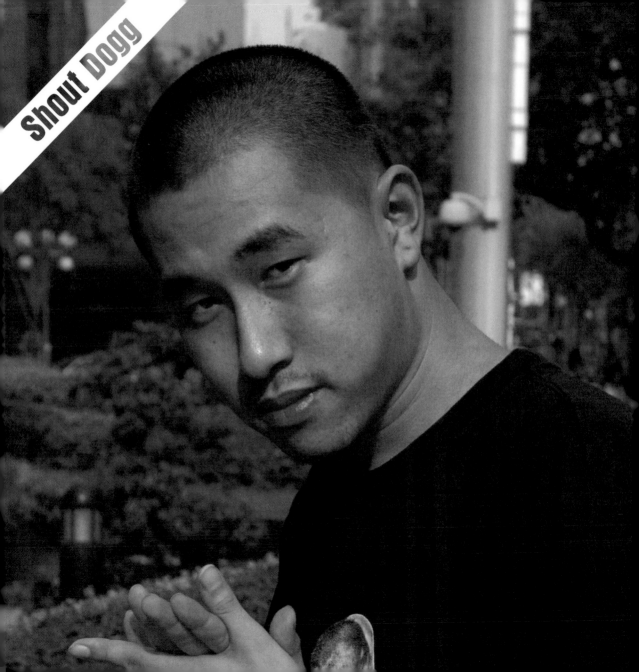

Ah you know, the boys at 17 or 18 are always very restless. Yeah, always breaking this, breaking that, break the roof and always yelling at home. So the mother say, "Oh boy, why you always make the loud noise." At that time I started into this hip-hop stuff so I got to name my street name. I am always yelling so I named myself Shout Dogg. At that time my favorite artist was Snoop Dogg so I just made a little combination. Actually my English name is Benjamin. I don't know why I chose this name. You know like five or seven years ago it was kind of fashion to have an English name. I thought this name is cool for me. I found it in the dictionary. I learned a little English at school. You know the school only learn the basic stuff. I love hip-hop so I learn by listening to music and watching movies. I think this is the better way.

My friends usually call me Shout. When I was 20 I would shout a lot but now I am 22-years-old. But when I am working I shout a lot. I am an MC. Most of the time I use some high stuff to make the people feel really happy. But before I do this kind of stuff performing a lot. I do music. I've got a crew called Bamboo. We've got five members. We make an independent album. We released it last year. We sell in hip-hop clothing stores in Shanghai and in stores in Beijing. Bamboo. When people hear the name Bamboo people will think it is very China. It means like strong inside.

My Chinese name means clever or bright. So Shining has a connection with my name. I think it is important to have an English name with meaning. I chose this name during my first job at a foreign company. Now I work for a Finnish company and at this company we only use our English name. My boss is foreigner, he comes from England. We can remember the English name but we may not know all the Chinese names. There are so many people.

Most of my friends and family call me with my English name. All of them are working for a foreign company.

In my work I am in charge of the export/import, warehouse, sourcing, administration etc. We are very busy so my parents take care of my daughter. In China it is different.

My daughter's name is Susanna, she is six. Before, I gave her a name but she didn't like it. Afterwards, I read names in the dictionary and then she says that is nice. She chose it herself. In kindergarten the teachers gave her an English name too. She will make the decision by herself in the future. Every week my daughter has English class for one hour. She doesn't like it. Sometimes I teach her words but she said, "Oh please say it in Chinese." She can't remember because she isn't in that environment. You should at least speak English otherwise you cannot communicate. I showed her a picture of Rome: "If you want to go there you should speak English."

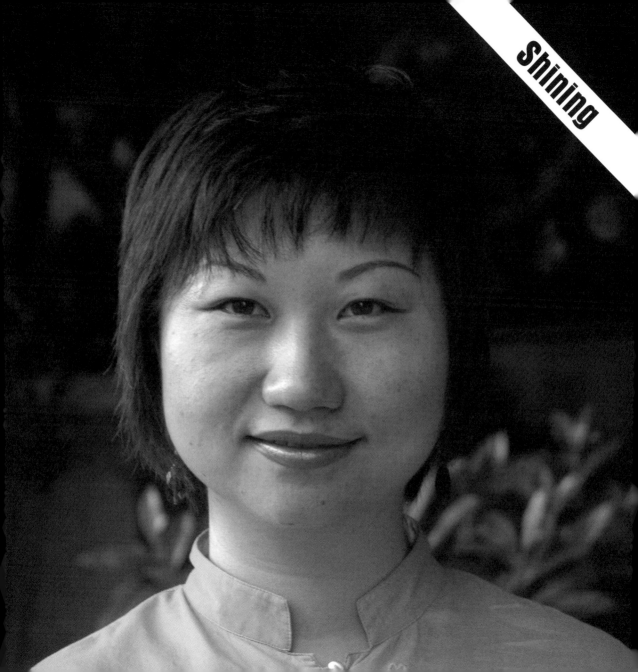

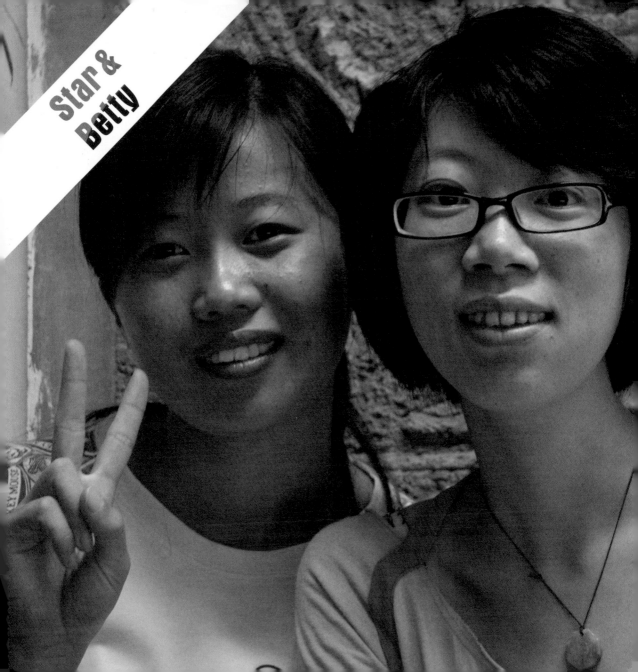

Star &
Betty

Star (left): When I was a little girl my mother always sing a song. It means when star in the sky and one person on the earth. I think I am the person on the earth and the star too. Because I think when we are on the earth and we look, the star is very small but very cheering. I think the person on the earth also has the same life as the star.

Betty (right): With a lucky draw give me. In junior school my teacher gave me this name. Yes, I like it; it is easily to call. In junior school my teacher write many names in a bowl. Every student chooses one name. So I choose this name because it is easy to remember. I hope it will very looks like education, looks lovely.

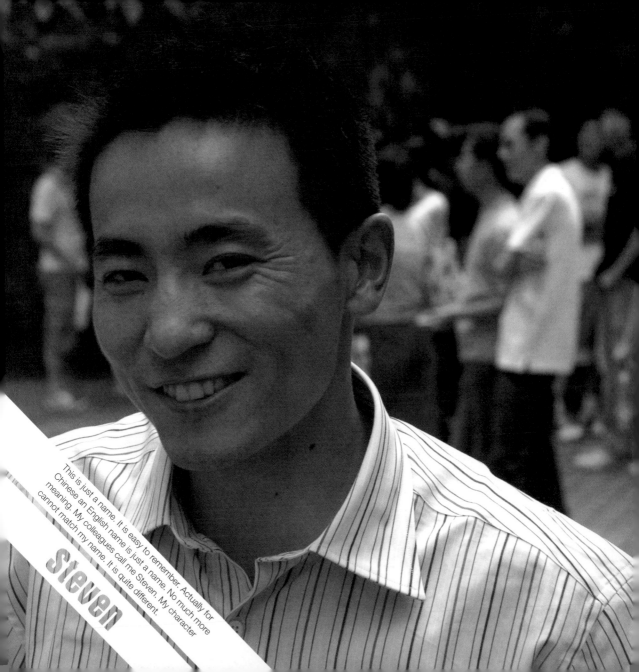

This is just a name. It is easy to remember. Actually for Chinese an English name is just a name. No much more meaning. My colleagues call me Steven. My character cannot match my name. It is quite different.

Steven

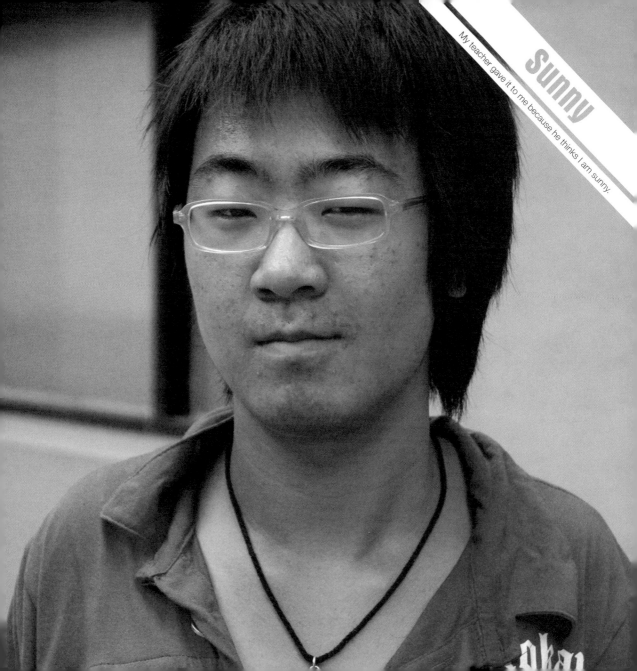

It's the same with my Chinese name: Shen Yun Xiong. I like dancing tango. From small my ears were not good. I could not speak. So I didn't study. My parents wanted me to learn so they teached me. I have lived in New York for seven years. My daughter lives there. She likes to travel. My parents wanted me to look more like a boy so one of my characters is a boy's name: Xiong Yun. It has two fires in its character. I was born in the seventh month on the 23rd. People that are born in this period lack fire. So my second character has two fires so I won't lack it.

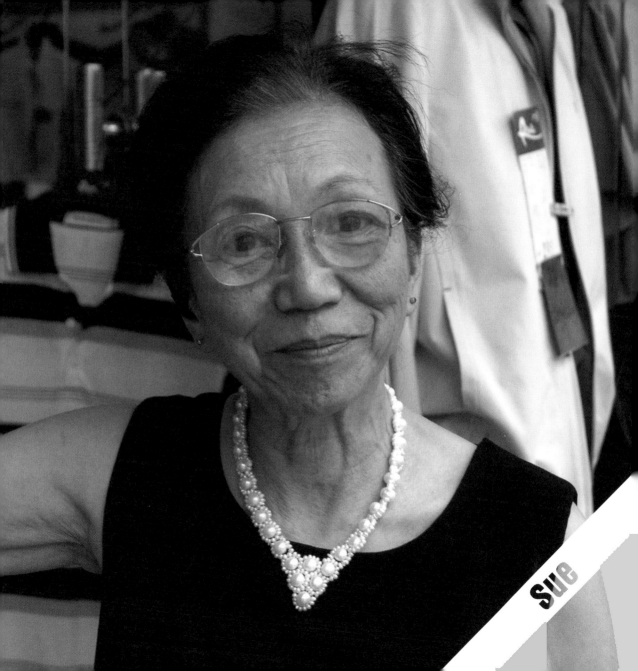

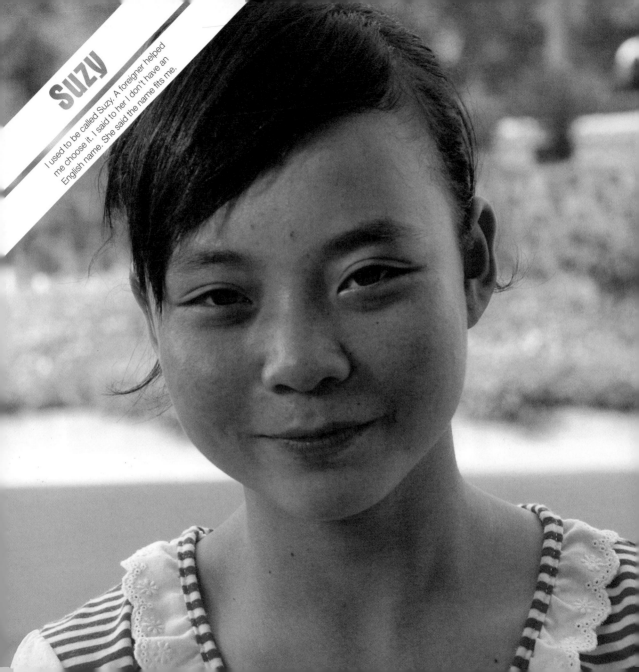

Suzy

I used to be called Suzy. A foreigner helped me choose it. I said to her I don't have an English name. She said the name fits me.

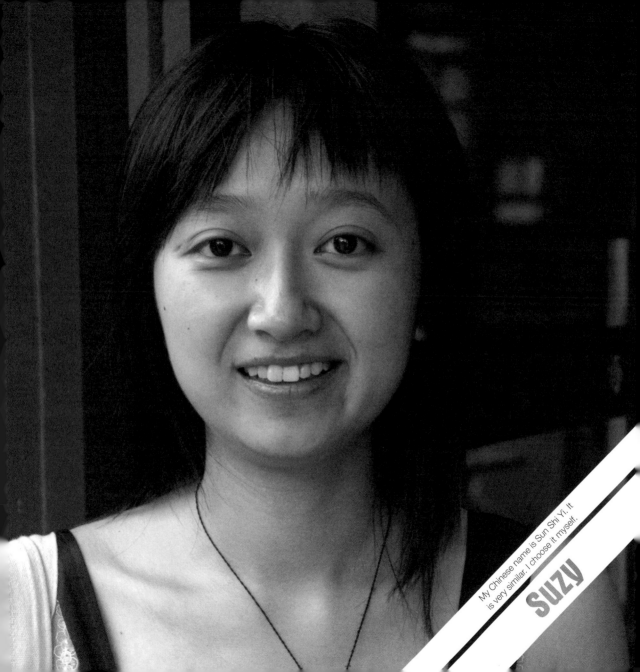

My Chinese name is Sun Shi Yi. It
is very similar. I choose it myself.

suzy

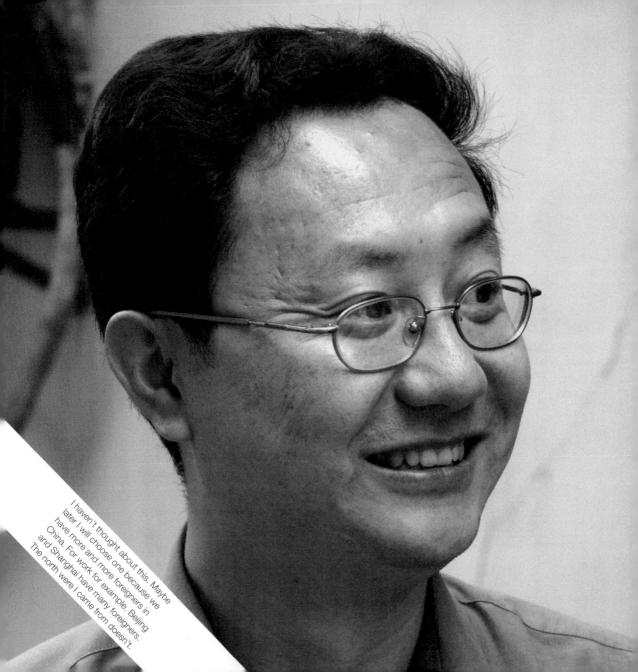

I haven't thought about this. Maybe later I will choose one because we have more and more foreigners in China. For work for example. Beijing and Shanghai have many foreigners. The north were I came from doesn't.

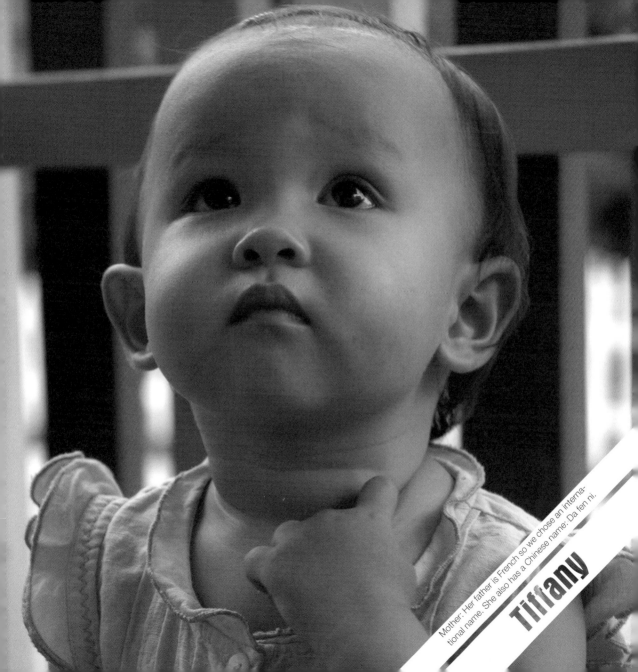

Mother: Her father is French so we chose an international name. She also has a Chinese name: Da fen ni.

Tiffany

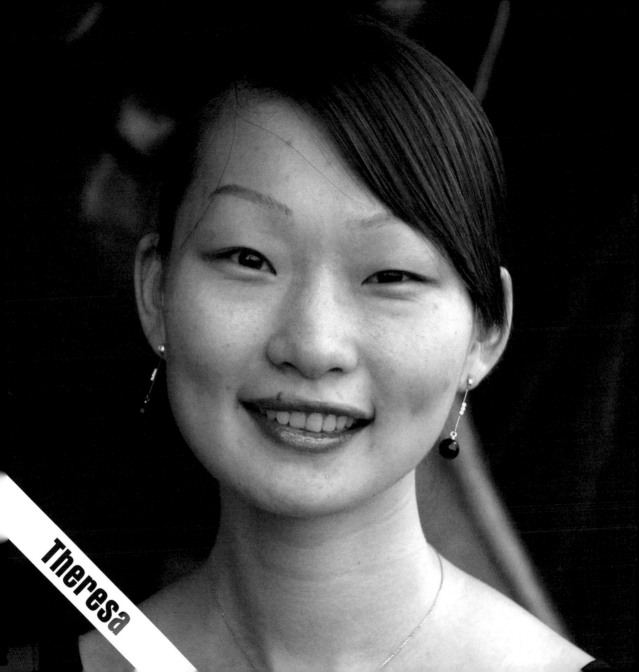

This name is just given by one of my best friends. Actually my previous name is Lili. And when I transferred to my new company, the current company I working for, my boss asked me to change my name because he say, "Oh, too many Lili's here," just change another name. So I just asked my friend if any available names you can give me? I don't know the meaning. I just look at the dictionary. I first pronounced the name wrong. My boss asked me if it is the correct pronunciation.

Another Lili working with me in the same office. When my boss call and say Lili I just look at him, "Anything I can do for you?" Oh, I don't call you. My boss then recognizes as little Lili or older Lili. I got this great job so I said to myself I can accept all the things you offer, even changing my name. Work is a little tough but I am young and have energy to learn more.

I also have foreign friends but my best friends are my colleagues. My boss picked some people that are similar so we can become good friends. Maybe it is destiny or faith. I trust that very much. Chinese people trust it very much. Even young people. My Chinese name and English name don't have a relation with my destiny. Just good sound and pronunciation. Lili is similar with my Chinese name. I also asked my parents why did you choose the name Lili. They said it was just for the good sounds.

Tim (left): Tim because my Chinese name is little bit like. The pronunciation is similar. We studied English at a Chinese school. We have foreign teachers. We graduated here and live here. We don't use it here at the temple. Only between our friends. We usually use our Chinese name and our monk name. Our master chooses our monk named based on our character.

Rainman (right): I like this movie very much.

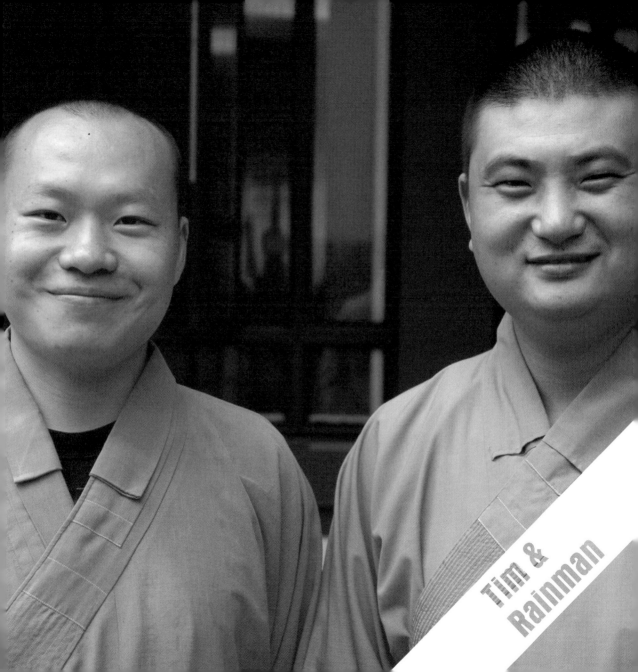

Tim & Rainman

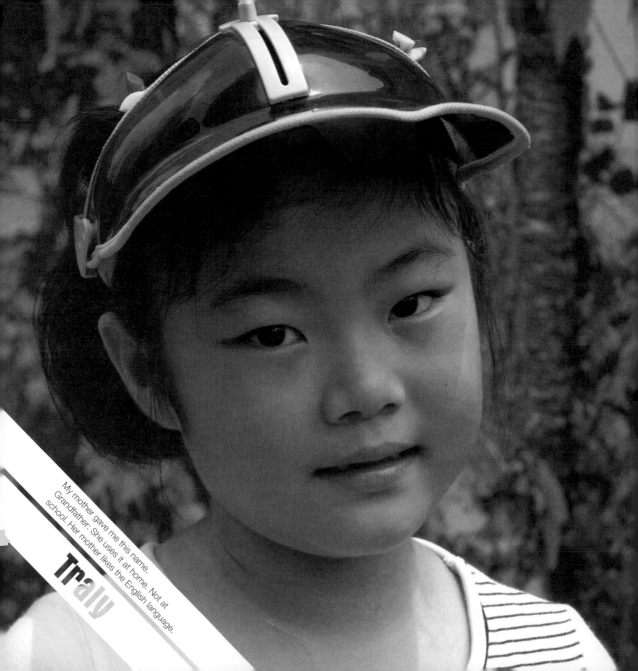

My mother gave me this name. Not at school. Her mother likes the English language.
Grandfather. She uses it at home.

Traly

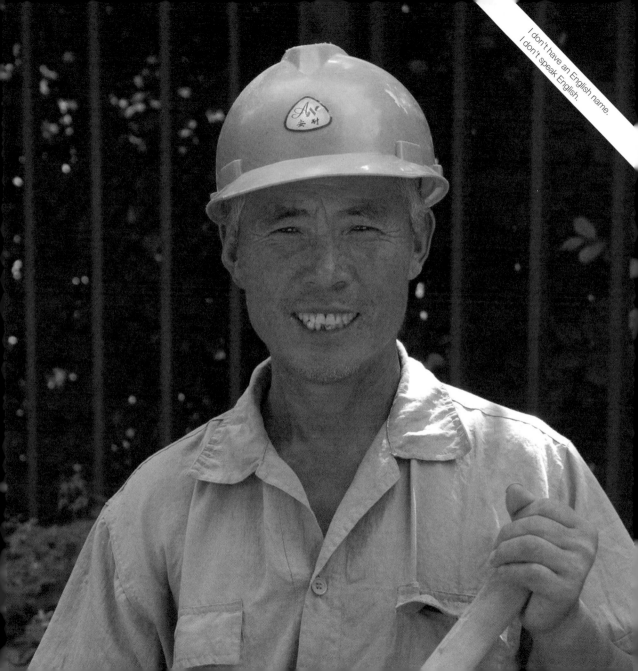

I don't have an English name.
I don't speak English.

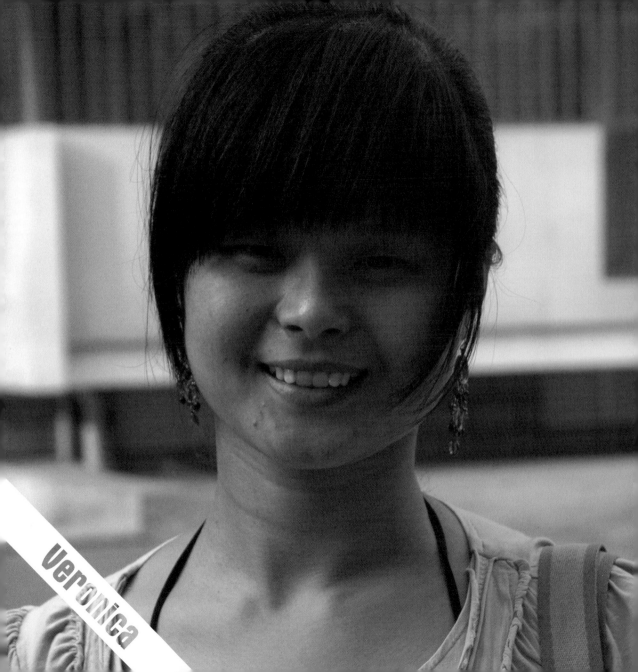

Veronica

Veronica has a European/Italian feeling. I like the coastal cities.

I saw American television series and European movies. There was a movie about two women named Veronica. They lived in a different time and space but they could feel each other feelings. That story is very interesting and funny.

It is easy to use on internet and for conversations. If you use an English name you become more international. My Chinese name is Wei Na. It sounds similar but it is not important because it is just convenient to use an English name. It's just an idea.

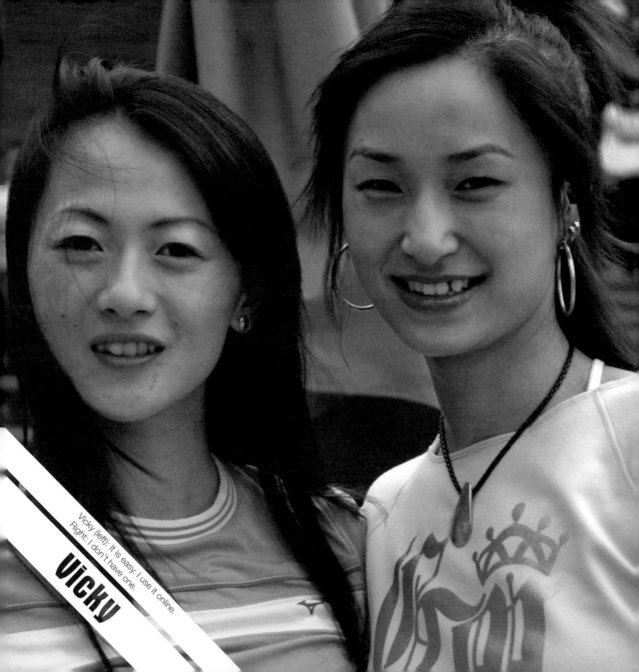

Vicky (left): It is easy. I use it online.
Right: I don't have one.

Vicky

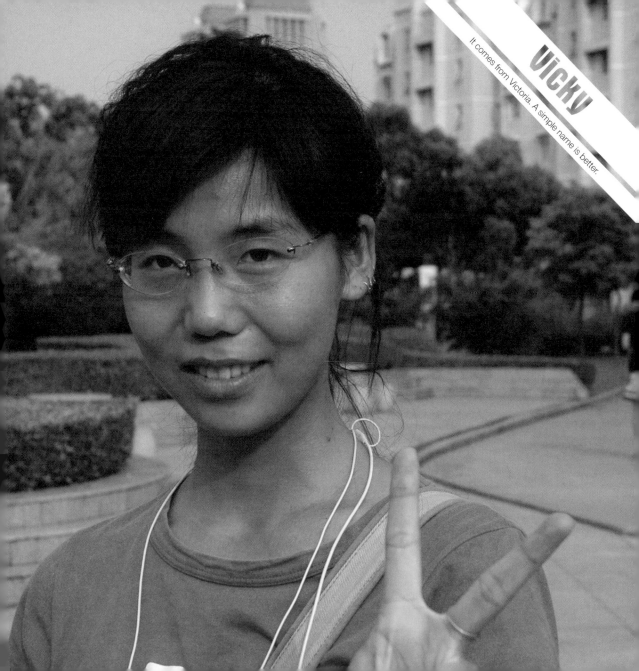

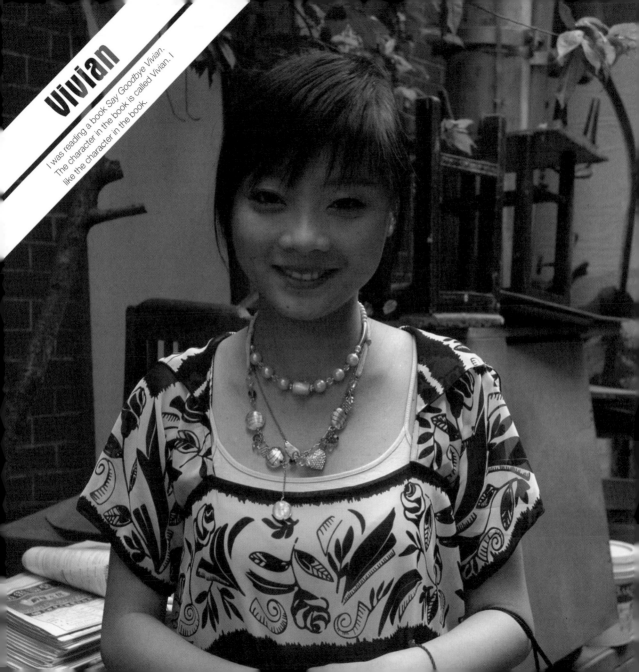

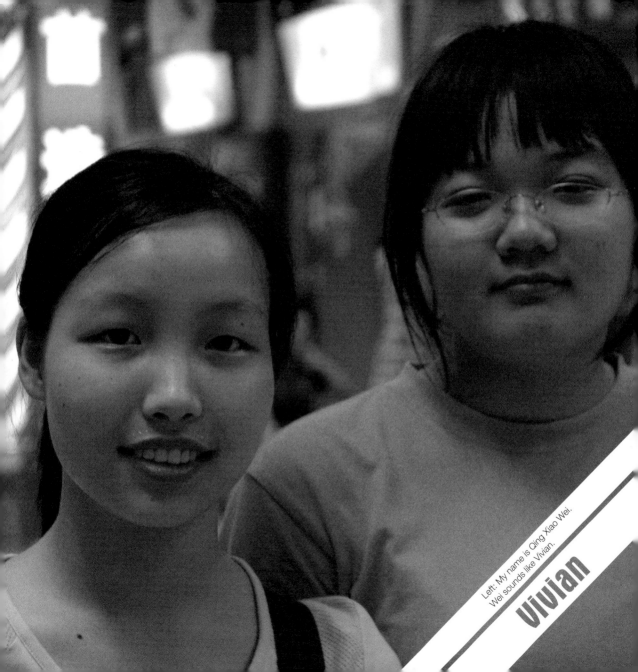

Left: My name is Qing Xiao Wei.
Wei sounds like Vivian.

vivian

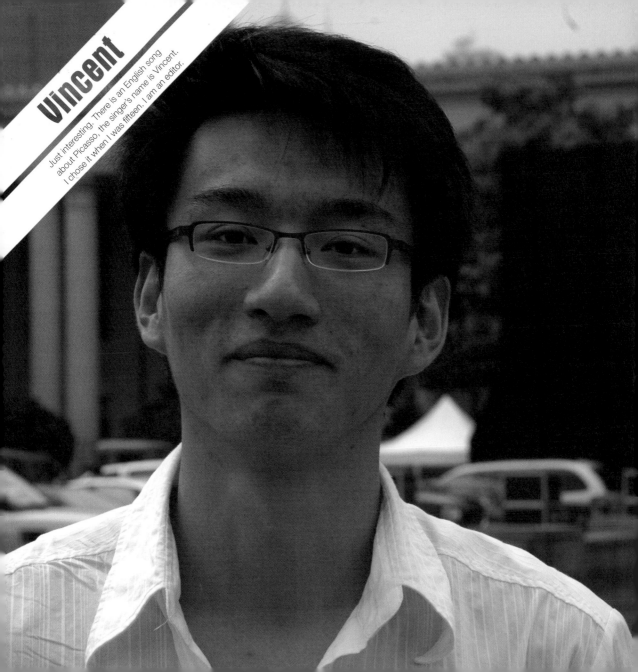

Vincent

Just interesting. There is an English song
about Picasso, the singer's name is Vincent.
I chose it when I was fifteen. I am an editor.

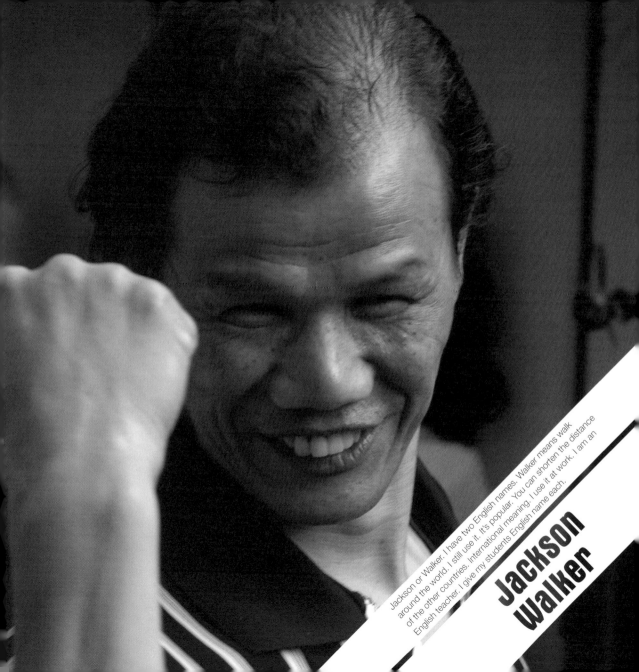

Jackson or Walker. I have two English names. Walker means walk around the world. I still use it. It's popular. You can shorten the distance of the other countries. International meaning. I use it at work. I am an English teacher. I give my students English name each.

Jackson Walker

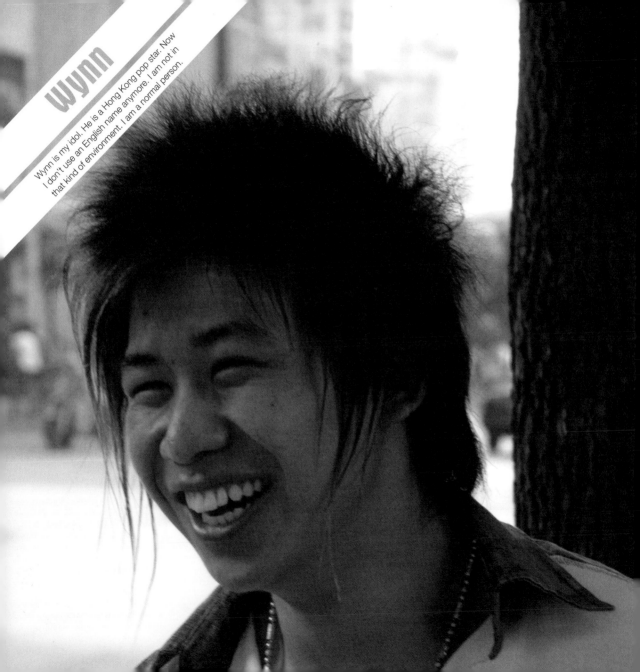

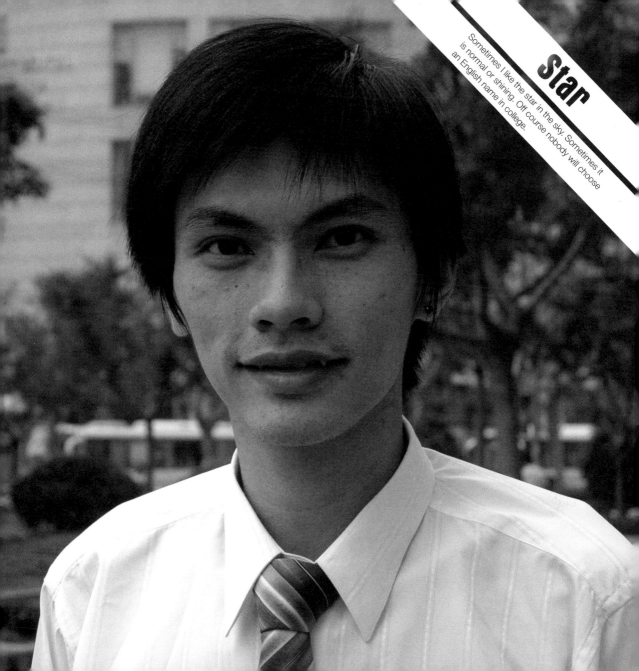

Star

Sometimes I like the star in the sky. Sometimes it is normal or shining. Off course nobody will choose an English name in college.

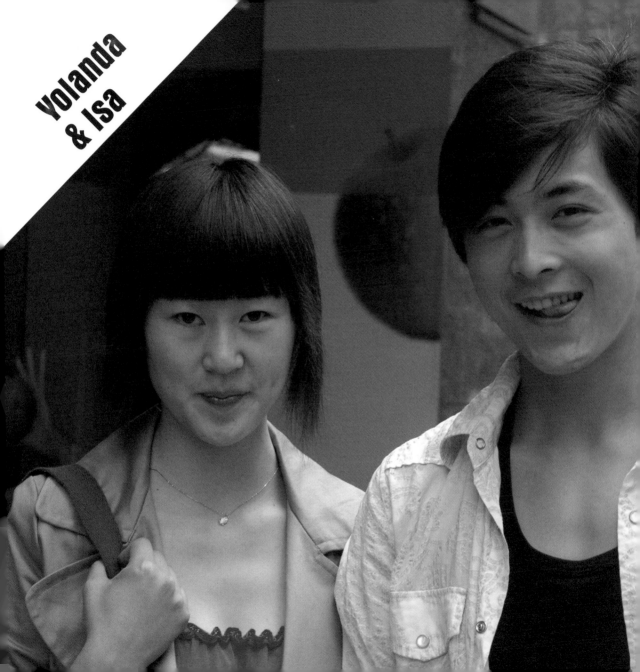

Yolanda (left): I think this is the most special name in all the English names. My boss asked me to choose one. They said everyone should have an English name. My major was music teaching.

Isa (right): I just like it. I study for performer and therefore I use an English name. I don't want to change my name.

I came up with it myself. It has no meaning, it's simple and easy to remember. All my friends call me Zat.

I have friends who live abroad and don't have an English name. I don't think using another name influences the Chinese culture. It's more a solution. A Chinese name can be very formal or too informal in certain circumstances. Using an English name can be a solution for that. Calling someone by his or her complete name sounds aggressive and by the first name sounds too informal.

It depends on the person if they have or don't have an English name. Some people think it's cool they can create their own identity. In that way they can create everything themselves and that makes them more special in their opinion.

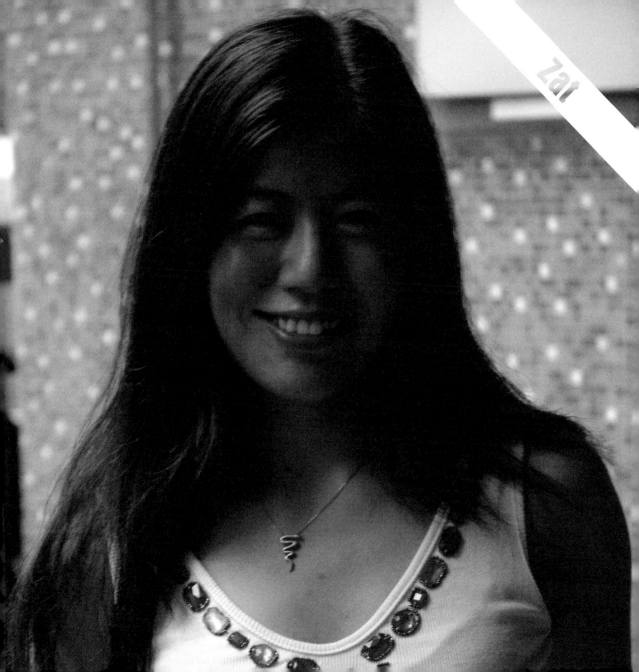

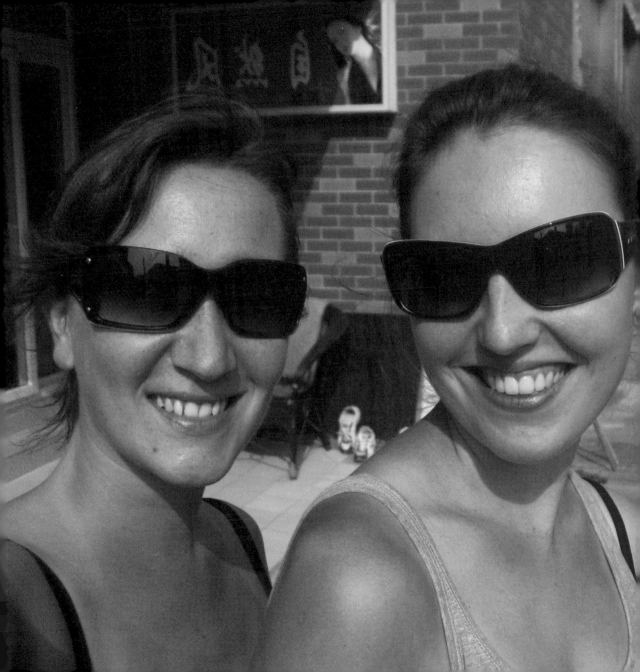

Valerie Blanco and Ellen Feberwee met each other during their study of "Concept & Brands" in the Netherlands. From day one they began working together. Upon completing their program, Blanco and Feberwee were both craving culture shocks so they moved to a country where they expected the biggest cultural differences: China. Study, work and travel were the main activities throughout their stay. Currently they live in the Netherlands again.

Of this project, they say, "Culture and society inspire us. We are happy to share our findings and hope they will enrich people's lives and businesses, if only in a small way."

For more information about this book and to post comments and stories, please visit:
www.chinese-identity.com